PICTURING SCOTLAND
ISLAY, JURA, COLONSAY & ORONSAY

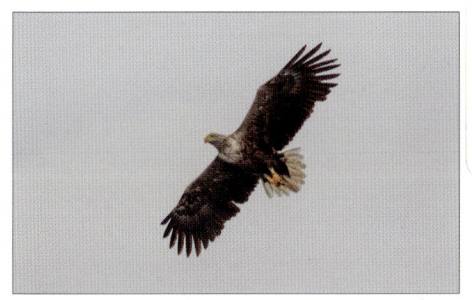

COLIN & EITHNE NUTT
Authors and photographers

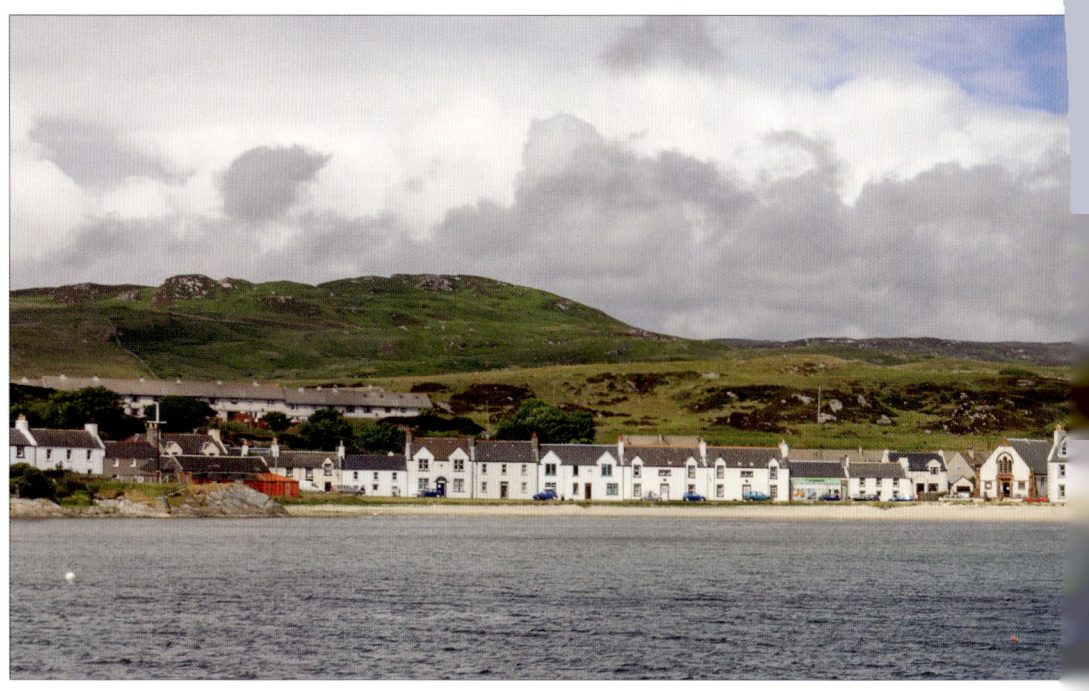

2 If taking the ferry from Kennacraig to Port Ellen, a scene like this will be your first impression of the island of Islay. Port Ellen is the main settlement on the south of Islay.

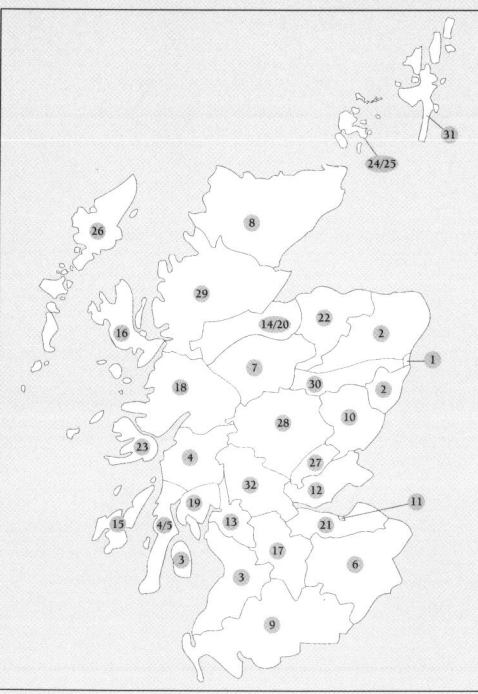

1. Aberdeen
2. Aberdeenshire
3. Arran & Ayrshire
4. Argyll
5. Southern Argyll
6. The Borders
7. The Cairngorms
8. Caithness & Sutherland
9. Dumfries and Galloway
10. Dundee & Angus
11. Edinburgh
12. Fife, Kinross & Clackmannan
13. Glasgow
14. Inverness
15. Islay, Jura, Colonsay & Oronsay
16. The Isle of Skye
17. Lanarkshire
18. Lochaber
19. Loch Lomond, Cowal & Bute
20. Loch Ness
21. The Lothians
22. Moray
23. Mull & Iona
24. Orkney
25. Orkney in Wartime
26. The Outer Hebrides
27. The City of Perth
28. Highland Perthshire
29. Ross & Cromarty
30. Royal Deeside
31. Shetland
32. Stirling & The Trossachs

The remaining four books, Caledonia, Distinguished Distilleries, Scotland's Mountains and Scotland's Wildlife feature locations throughout the country so are not included in the above list.

ISLAY, JURA, COLONSAY & ORONSAY

Welcome to the Southern Hebrides!

There's nothing like a journey by sea to prepare the traveller for the joy of disembarking and what better place to do so but on these islands! Colonsay and Oronsay are separated by a Strand whereas Islay and Jura are separated by a Sound. They are known collectively as the Southern Hebrides. As they lie in such close proximity, one might expect them to be very similar. However, each one is surprisingly different in character. They *feel* different too.

It's perfectly possible to visit them all in one trip, sailing from Kennacraig (or alternatively Oban if visiting Colonsay first). Colonsay is smaller than Islay and Jura – about 10 miles long by two miles across and is green, lush and fertile. Consequently, it makes a good home for all manner of flora. Its 135 inhabitants work in agriculture, oyster-farming, fishing, making honey, brewing, arts, crafts and a bookshop, a pretty eclectic mix for a small population. It is a welcoming island with a great sense of peace. It has an 'up-hill, down-dale' landscape providing some challenges to cyclists and walkers but with the reward of glorious views across to the surrounding islands and mainland. Neighbouring Oronsay, with its Priory, is semi-detached from Colonsay and can be reached on foot at low tide across The Strand. The island is still farmed.

Islay (pronounced 'Eye-la') is the southernmost. It played its part in the history of Scotland in the days of the MacDonald Lords of the Isles, with their centre of power at Loch Finlaggan. This dynasty ruled the west coast islands and parts of the western mainland from Kintyre (southern Argyll) to Lewis (Outer Hebrides). With a resident population of approximately 3,200, it covers

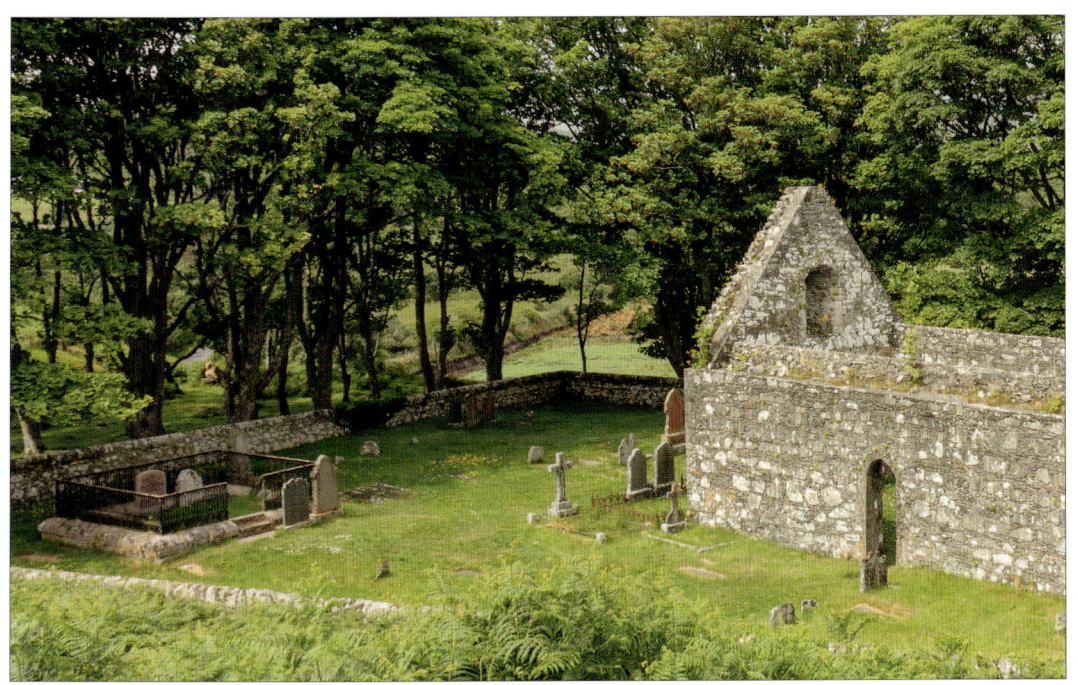

The ruins of 13th-century Kildalton Church, on the south-east corner of Islay about 10 miles from Port Ellen, are largely complete although roofless. As can be seen, much remains in the churchyard.

an area of 231 square miles/600 square kilometres and, due to its complex shape, has a rugged coastline 130 miles long! That coastline can be serenely beautiful or incredibly fierce, especially impressive (and dangerous) in storms. Islay's character ranges from wildness to gentleness. As for whisky, there are eight distilleries, all of which are open to visitors. A new one will open in 2018 at Ardnahoe in the north and there are plans to revive Port Ellen Distillery in the south.

 Neighbouring Jura must be one of the wildest of Scotland's inhabited islands. The iconic Paps command the island. Similar in size but different in shape to Islay (about 30 miles north to south and eight miles across), Jura's population is about 200. For comparison, when Jura's population was first recorded in 1845, the figure was 1,400. Prior to that, periodic famines and land clearance took their toll, so its maximum number was probably higher. As a result of such de-population, the island is now a land largely empty of people. The island's only road runs from the ferry terminal at Feolin via the village of Craighouse up the east coast just past Ardlussa beyond which vehicle access is restricted. The rough track continues northwards. The present-day sparseness of habitation means that wildlife flourishes and every walk is a great adventure. One thing all four islands offer in common is the night-life – that is, on clear nights, to gaze in wonder at the heavens from the Dark-Sky environment thanks to very low levels of light pollution. Tthe clarity and brilliance of the stars and planets can take the breath away. So, whatever your interests or expectations, visiting the Southern Hebrides will open up a whole range of surprise encounters with the variety of landscape, wildlife and people – the island people who call these islands 'home'. This photographic journey starts with Islay, travels to Jura and continues to Colonsay and Oronsay.

Left: Kildalton Cross, also in the churchyard, is the finest intact high cross in Scotland, carved in the late 8th century. Right: look carefully at the signpost at the entrance to Ardbeg Distillery!

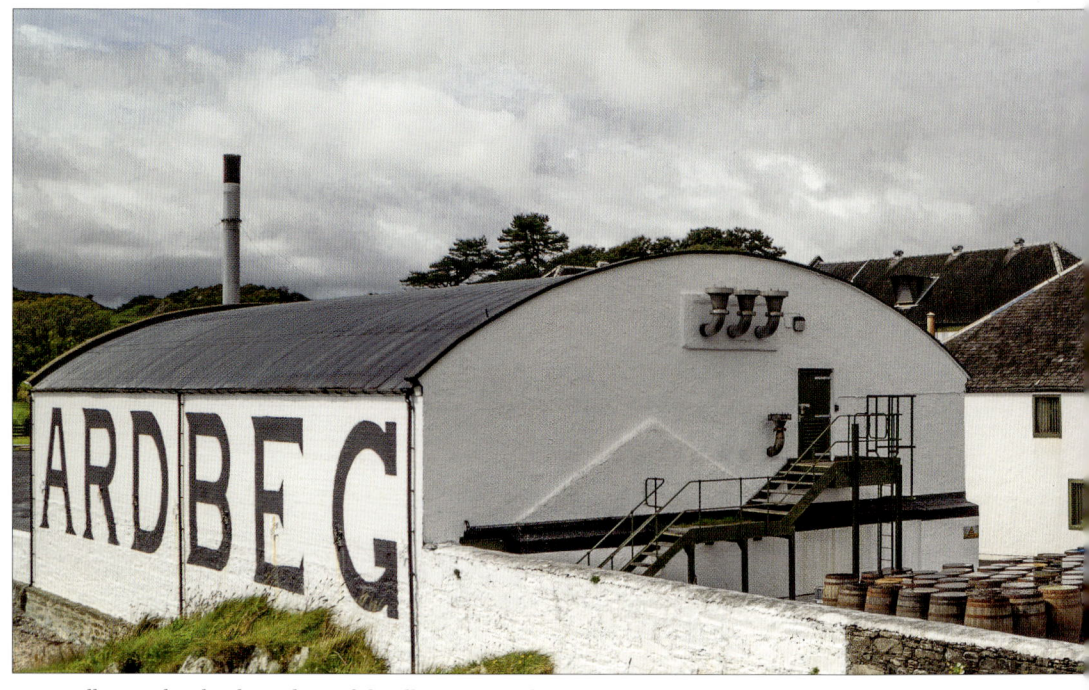

8 Ardbeg is the third in a line of distilleries east of Port Ellen. Its story began in 1815 when John Macdougall took out a licence to establish Ardbeg as a legitimate commercial concern. After many

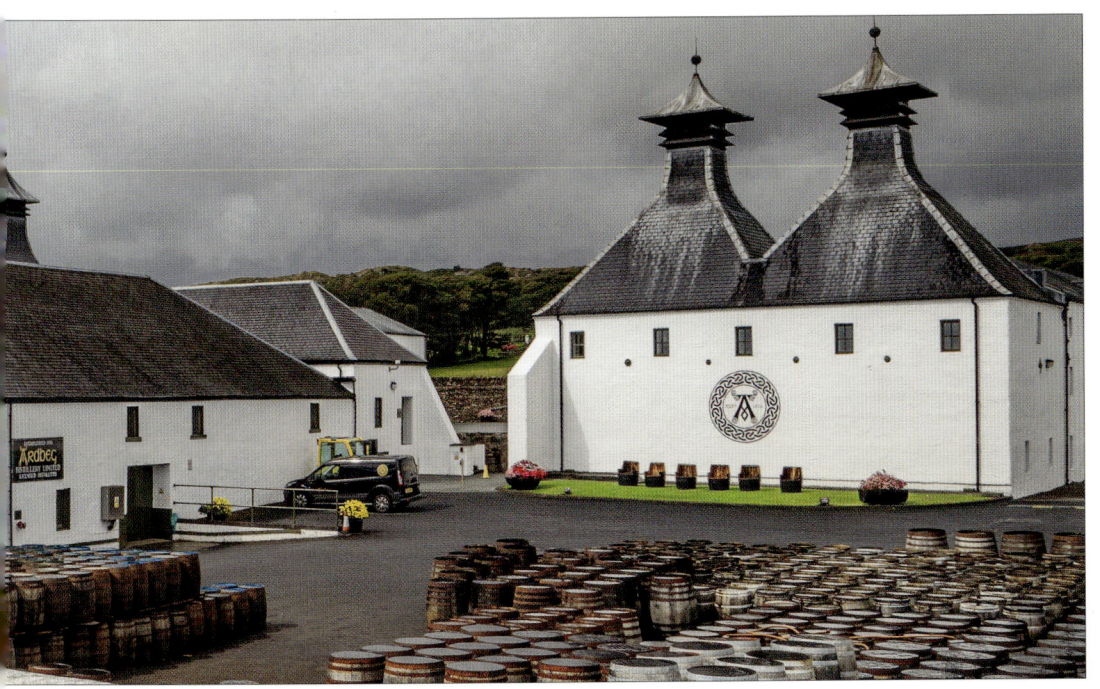

twists and turns in its story, it was 'mothballed' in 1981, but reopened in 1997. Commercially, it is now one of the fastest-growing Islay malts and winner of many awards.

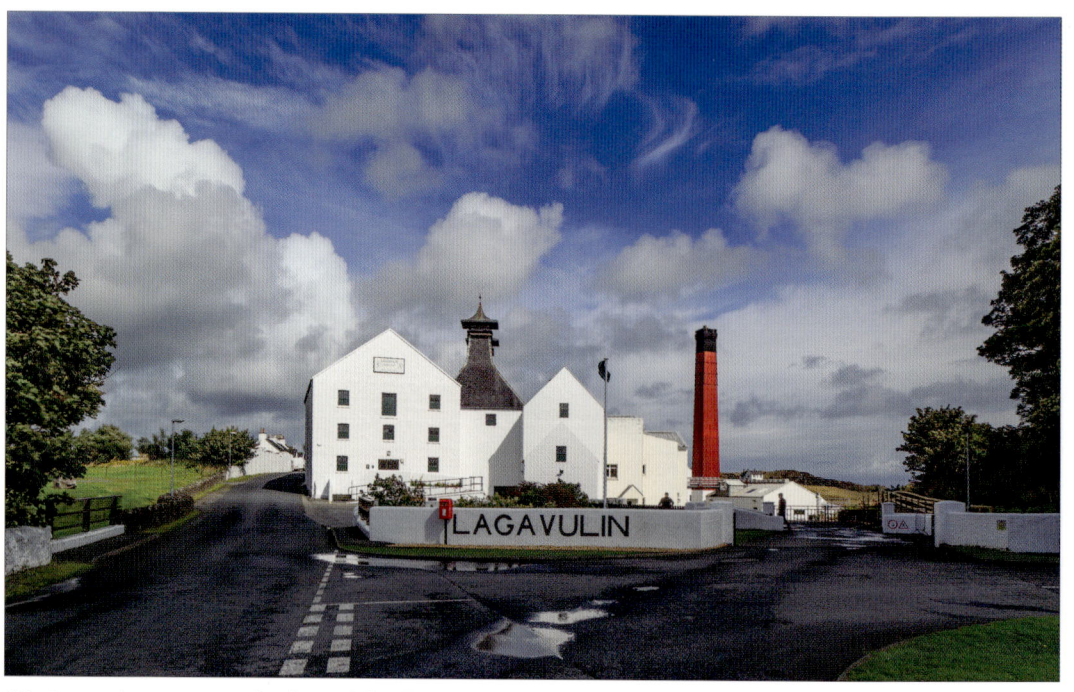

10 Lagavulin is next in this line of distilleries east of Port Ellen. Officially, it dates from 1816, though records show illicit distillation here as far back as 1742. Pictured under a wonderful Hebridean sky!

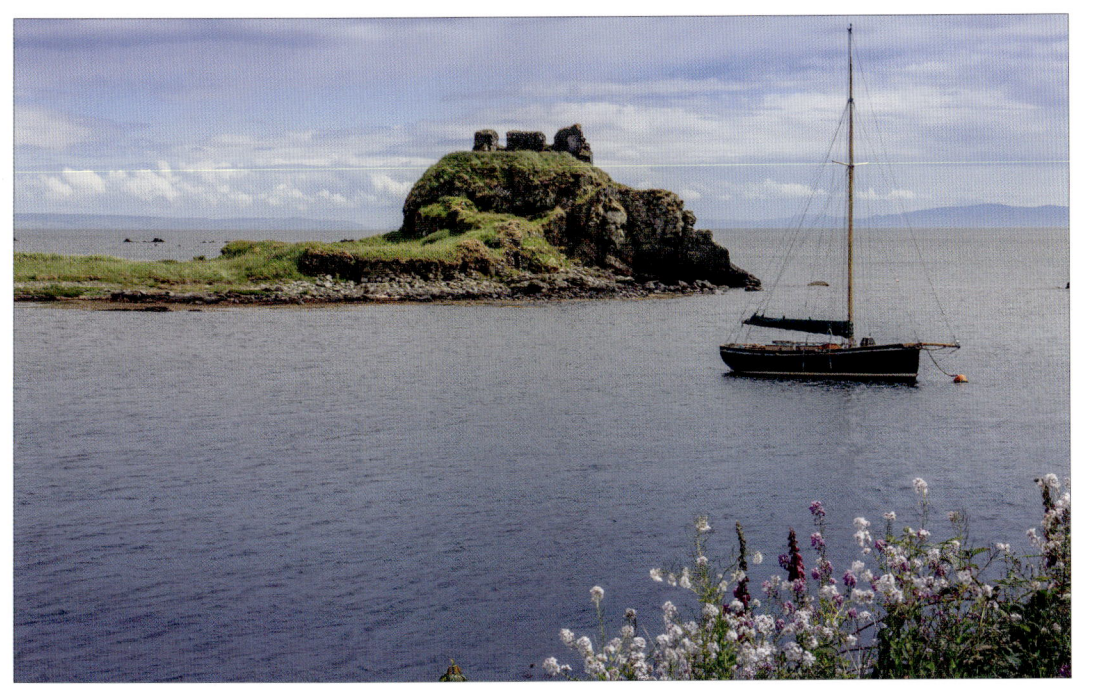

Dunyvaig Castle, overlooking Lagavulin Bay, was a fortress of the MacDonald Lords of the Isles built to protect their fleet. The castle ruins are still prominent today.

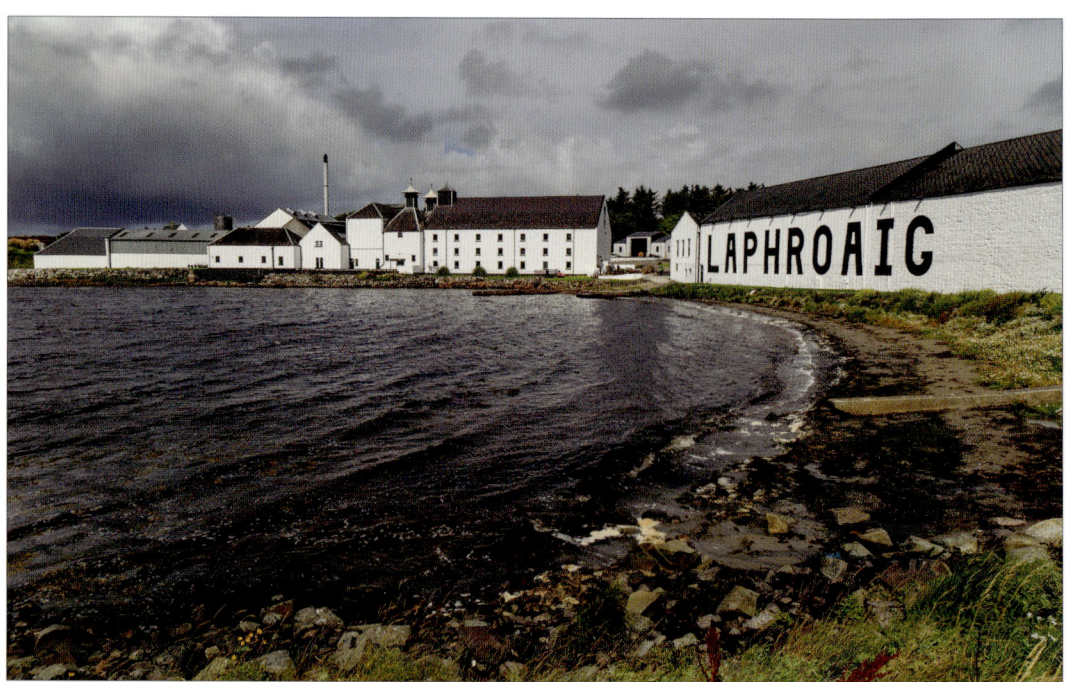

12 It is said that Islay has whisky in its soul, with no fewer than eight working distilleries (and more to come). Laphroaig (just east of Port Ellen) is one of them, famed for its peaty malt whiskies.

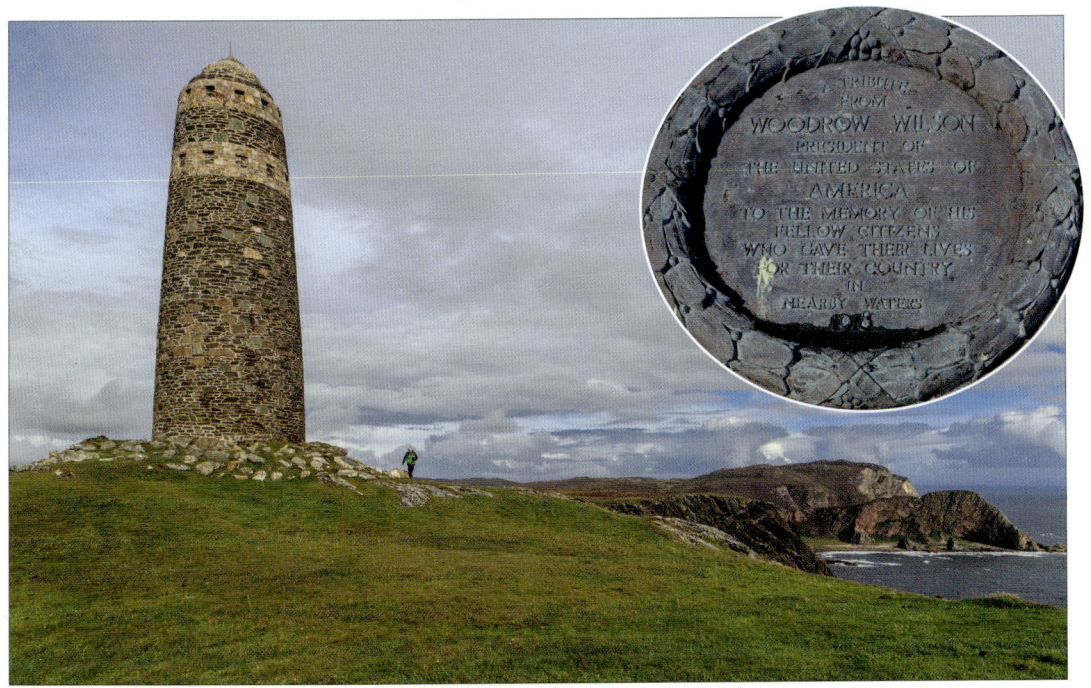

Now we move to the south-western corner of Islay, the Oa Peninsula, where the impressive American Monument stands atop 131m/429ft cliffs. It commemorates the loss of two troop ships in 1918,

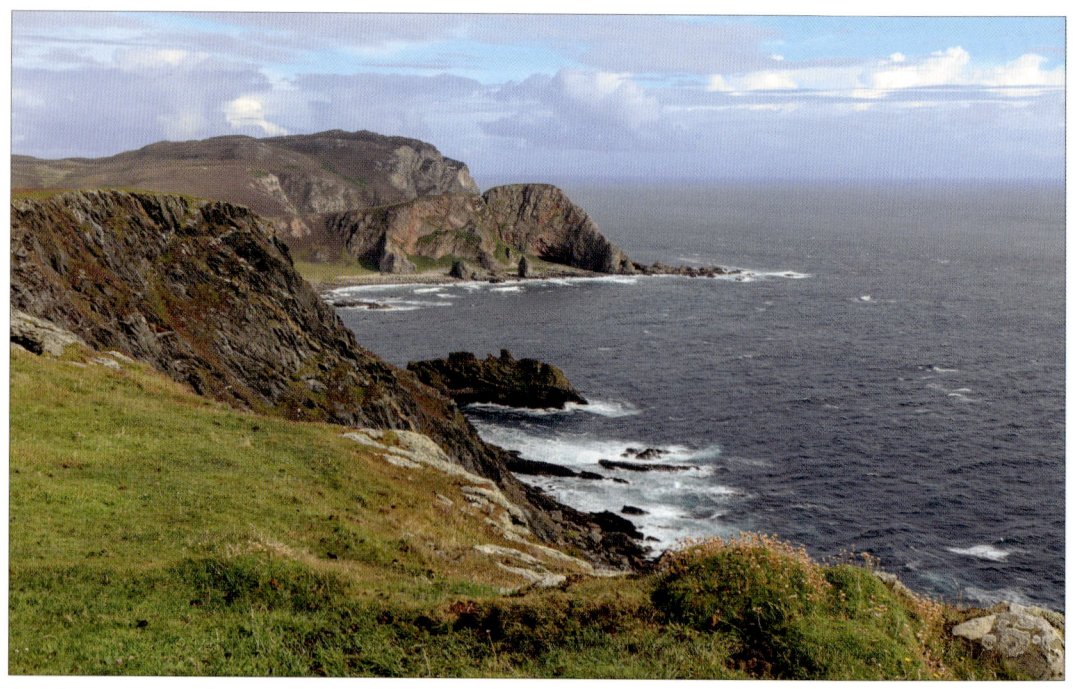

14 the *Tuscania* and HMS *Otranto*, both of which were transporting American soldiers. The *Tuscania* was torpedoed and the *Otranto* collided with another vessel during a storm. In total over 630 lives

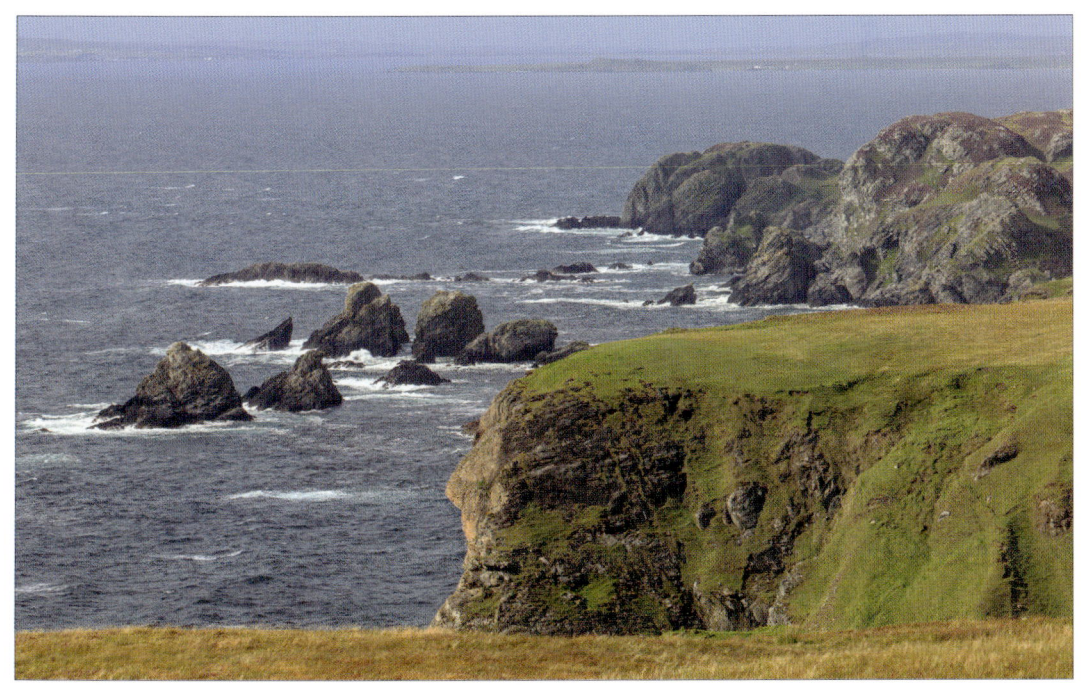

were lost. Opposite is the view looking east along the cliffs from the monument, while above is the equally rugged northerly aspect, looking across Laggan Bay.

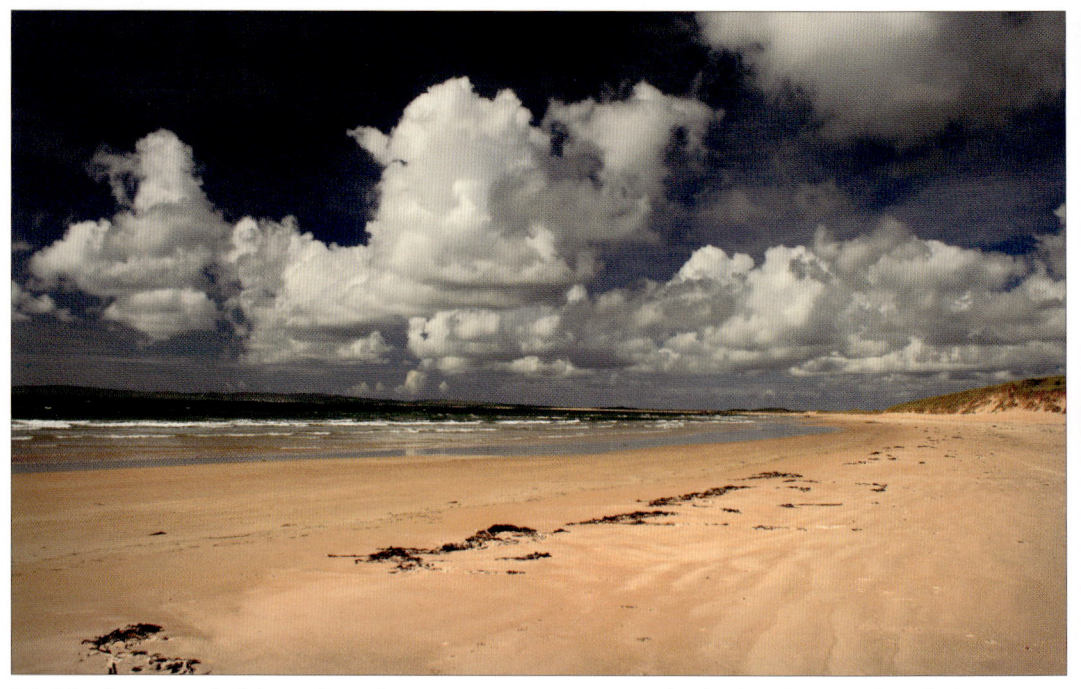

16 Islay has a wonderful coastline of great variety. Not surprisingly, this beach is simply called Big Strand and stretches along the six miles of Laggan Bay north of Port Ellen.

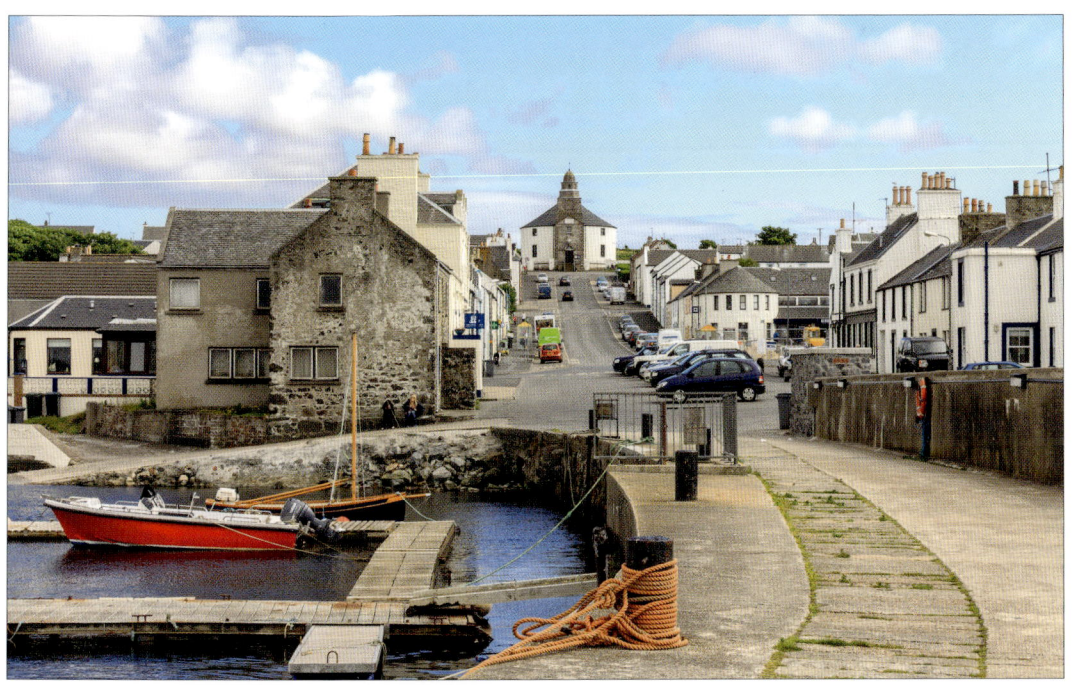

This is Bowmore, Islay's principal town and administrative capital. This view looks up Main Street from the harbour to the Round Church, parish church of Kilarrow, built in 1767.

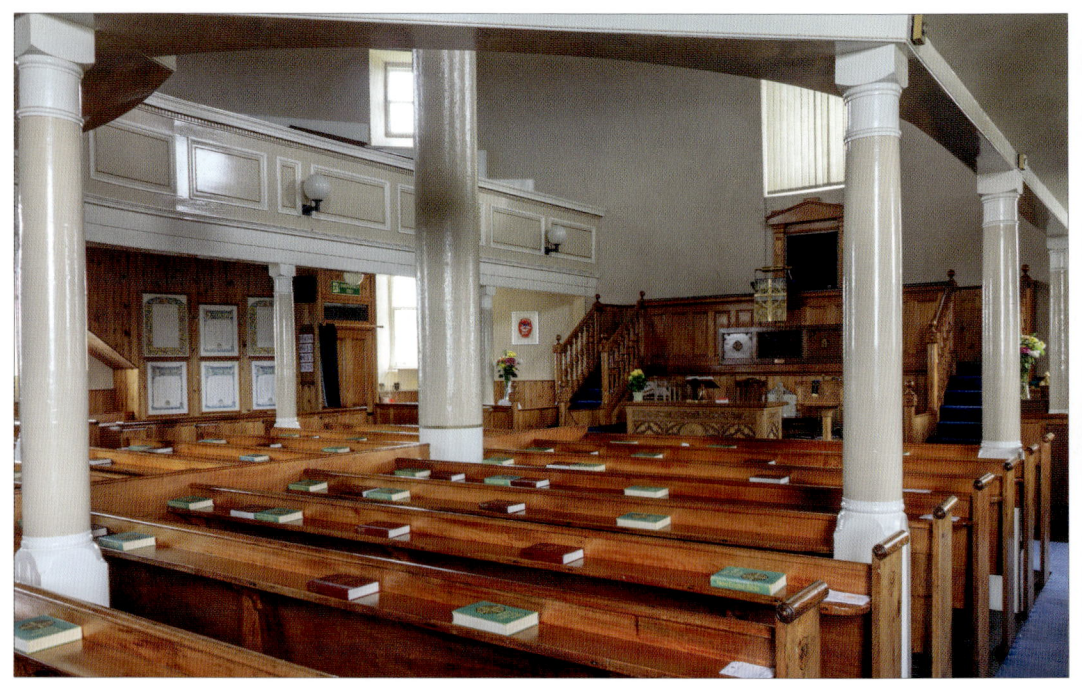
18 The church's beautiful interior: the story goes that it was built in a circular shape to make sure there were no corners for the devil to hide in!

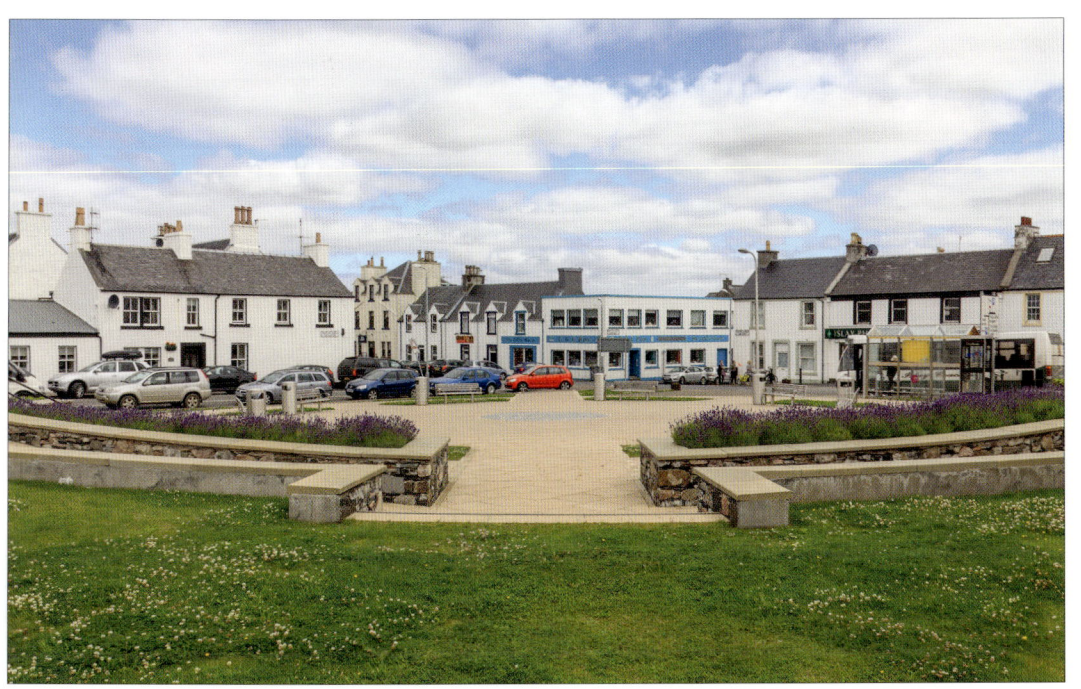

Bowmore lays claim to being the first planned village in Scotland, founded in 1768 and based on a grid pattern. This attractively laid out space is by the central cross-roads in the middle of the village.

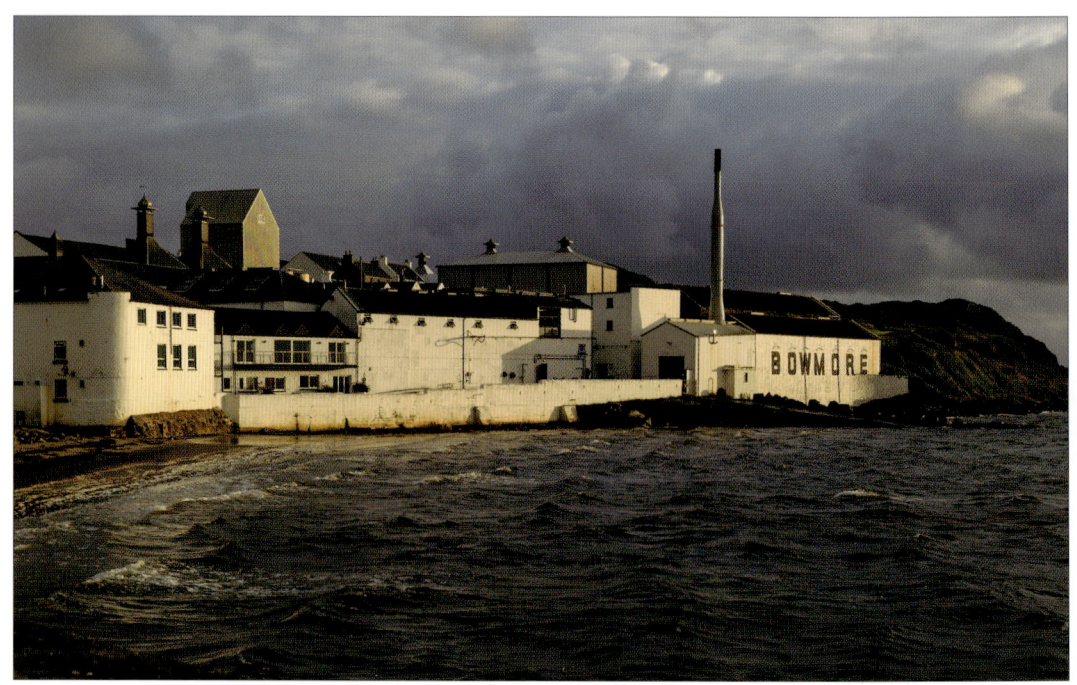

20 Bowmore Distillery is situated in the centre of the village but on the Loch Indaal waterfront, a pleasingly photogenic location. It is the oldest legal distillery on Islay, dating from 1779.

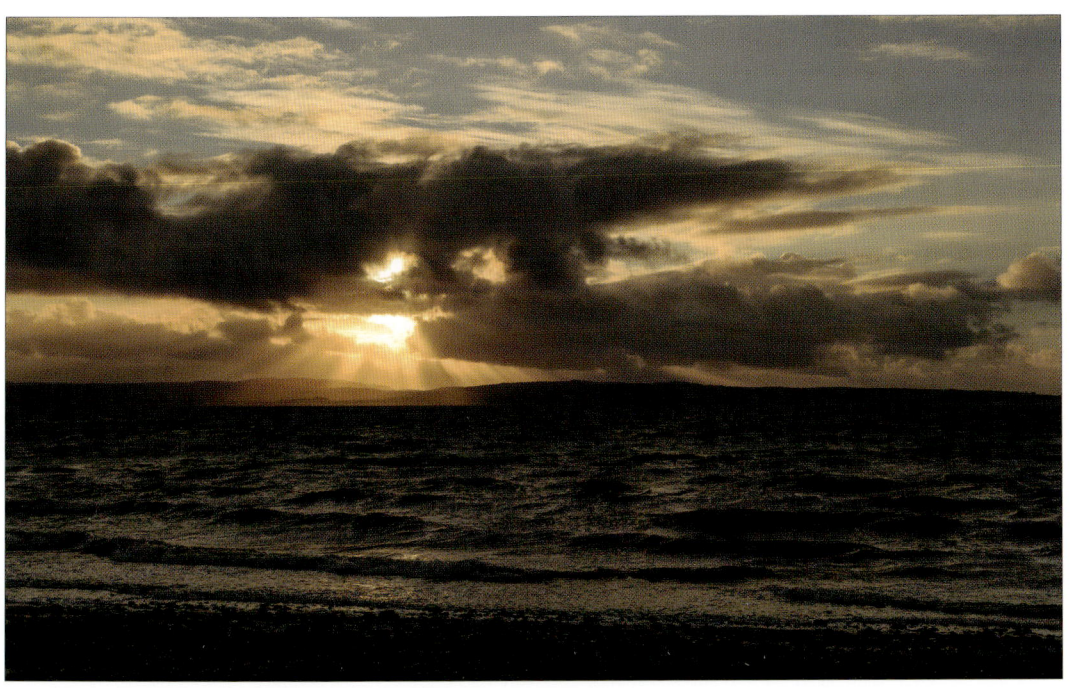

Loch Indaal is a sea loch in the form of a large bay which lies to the north of Bowmore. To its west are the Rinns of Islay, the land visible in the distance below the sunset.

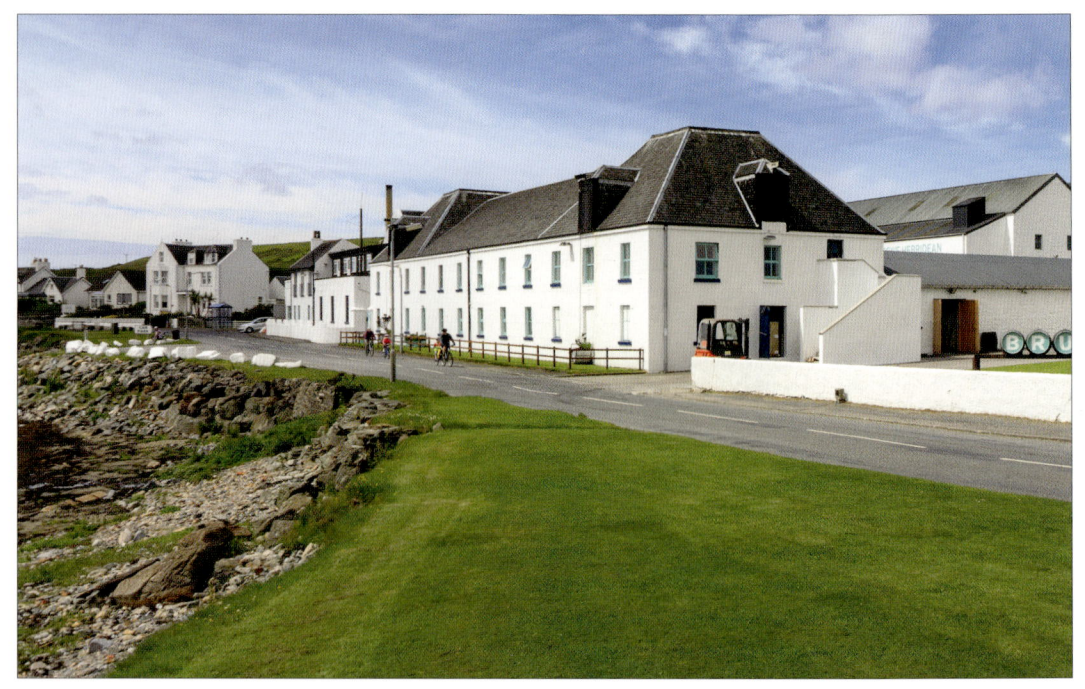

22 Yes, another distillery! Bruichladdich's philosophy is to be progressive Hebridean distillers, with an emphasis on innovative expressions such as *Octomore*. It is located on the Rinns of Islay.

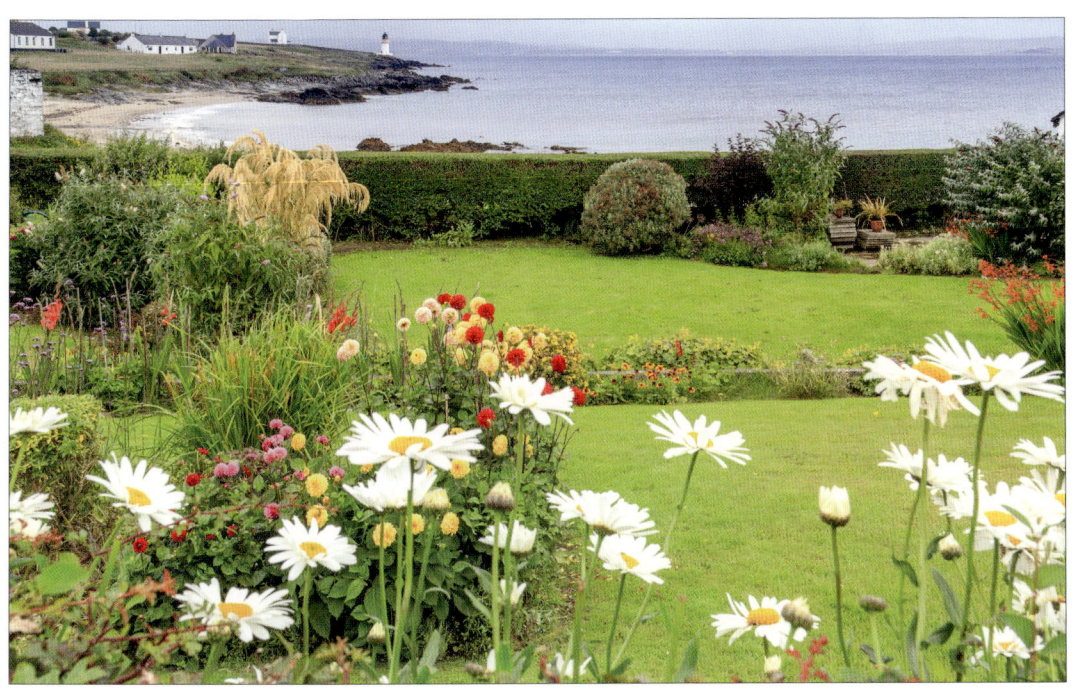

A couple of miles on from Bruichladdich is the charming village of Port Charlotte, where this hotel garden overlooks Loch Indaal. The Rinns of Islay form the island's westerly peninsula.

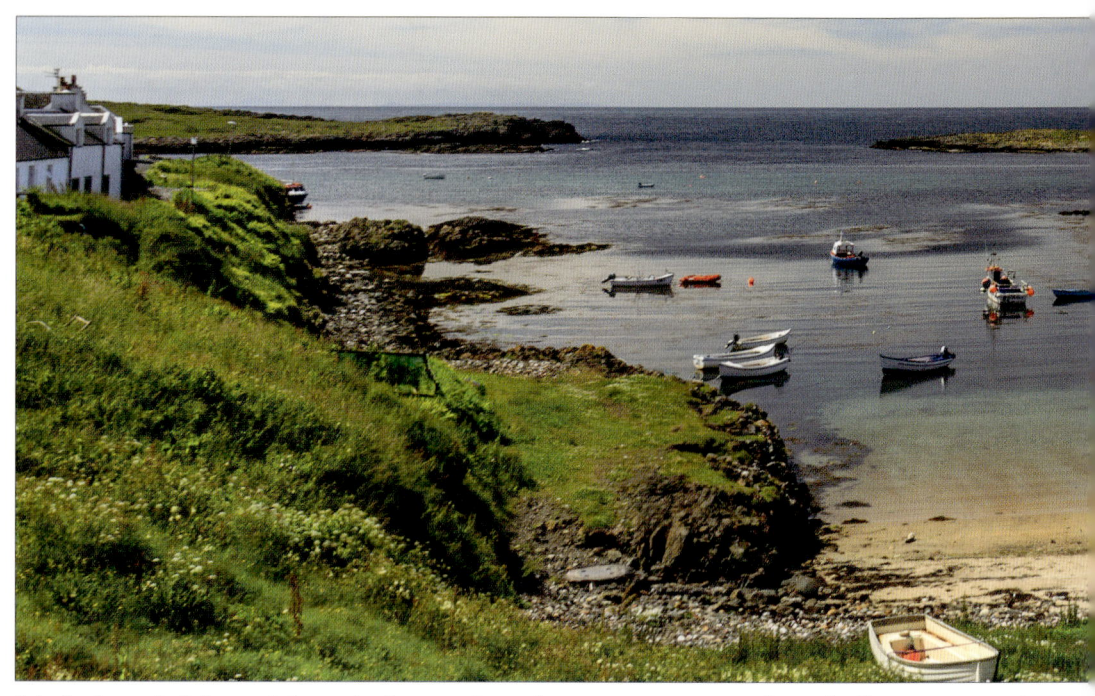

24 At the end of the road down the Rinns is Portnahaven, a picturesque planned village. It is a product of the 19th century, where fishing and crofting form the main sources of employment for the

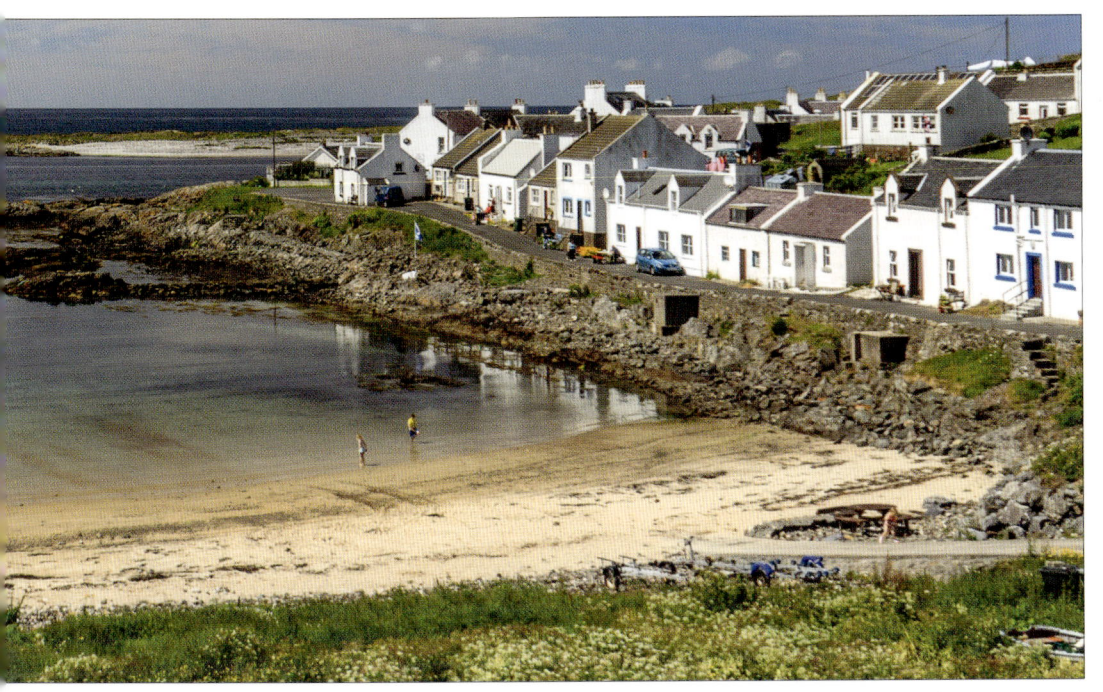

villagers. Nowadays there can be few better spots on the island for those seeking peace and quiet.

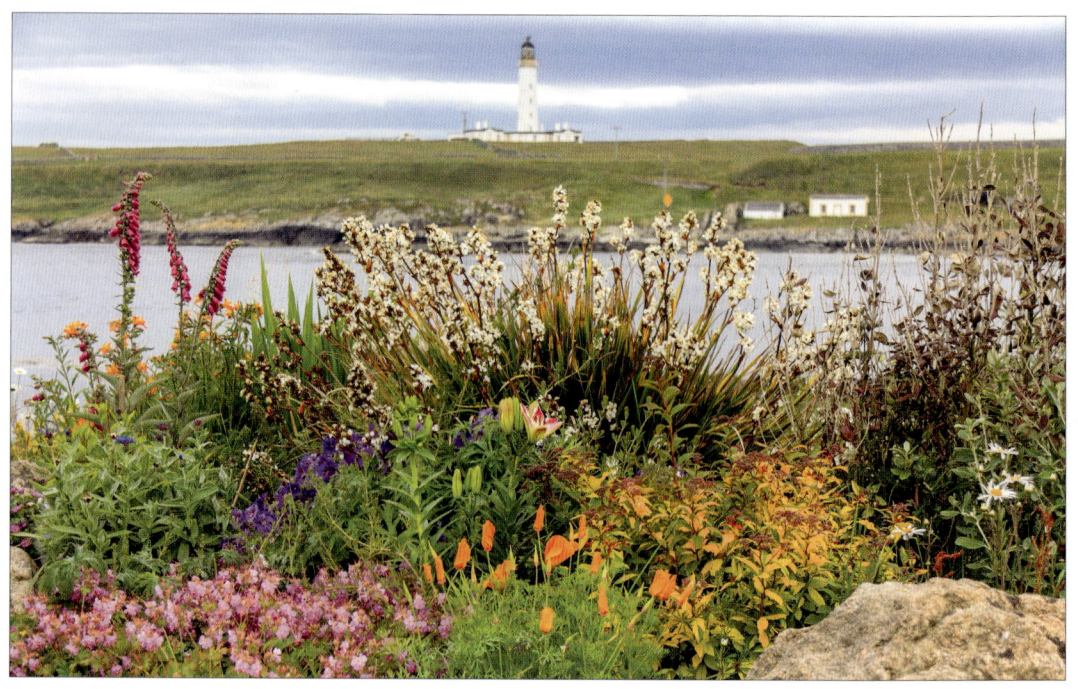

26 Port Wemyss is Portnahaven's neighbouring village, from where this image captures some of the local colour and, across the bay, Orsay Island and the 1825-built Rinns of Islay lighthouse.

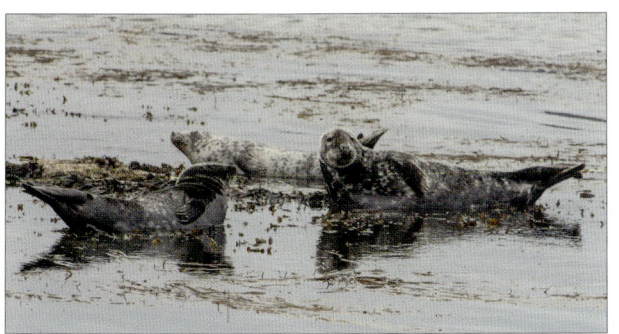
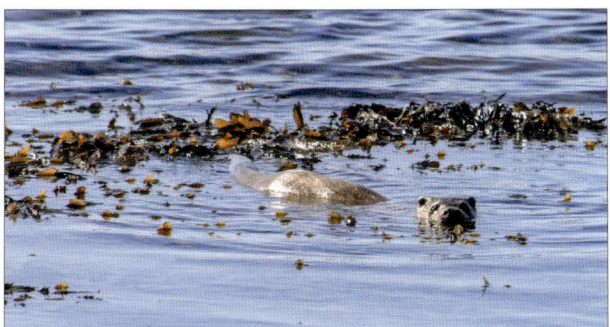
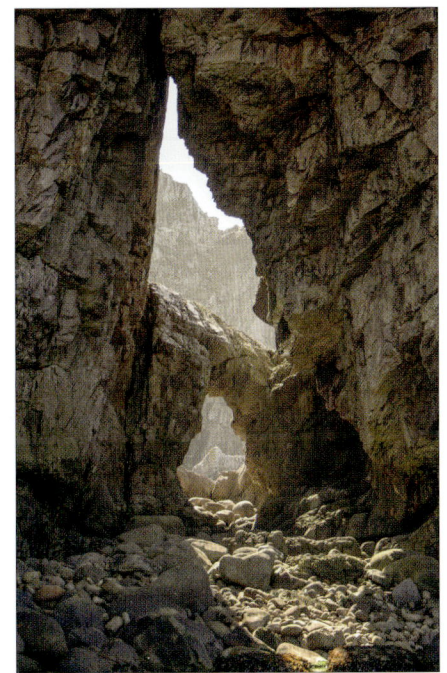

Left above: Portnahaven's sheltered harbour is a well-known resting place for seals; left below: seeing an otter is always a thrill; right: sea erosion has created this double rock arch on the Oa peninsula.

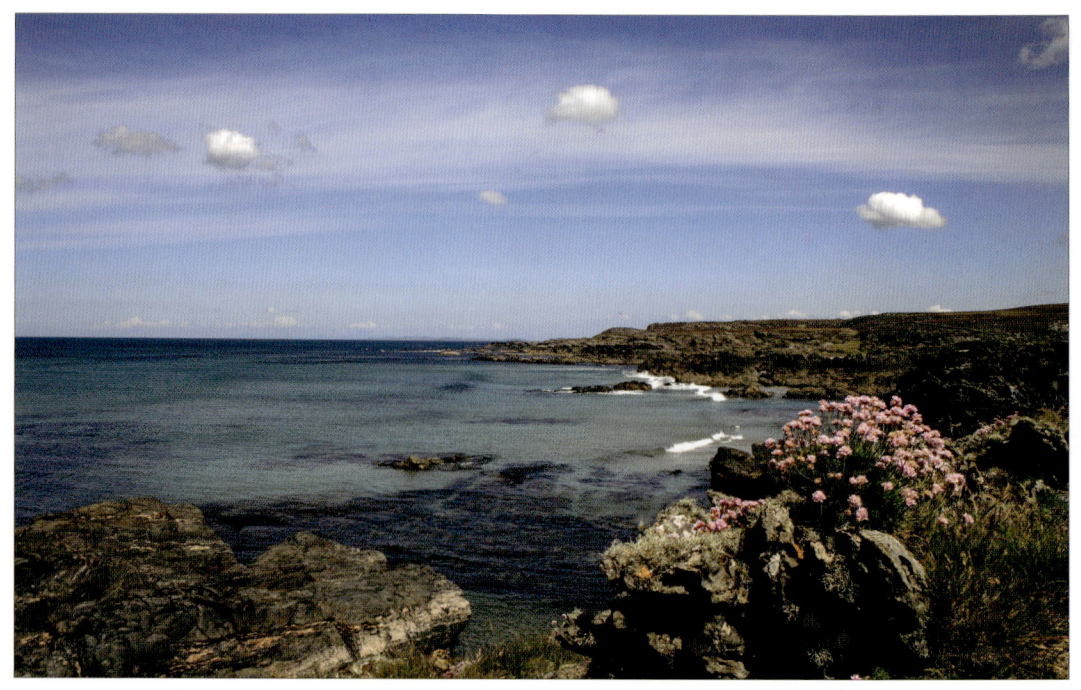

28 Moving north up Islay's west coast to Sanaig, an image of the island at its most alluring: the combination of pink-flowering Thrift, a cloud-dotted sky and aquamarine sea – so inviting . . .

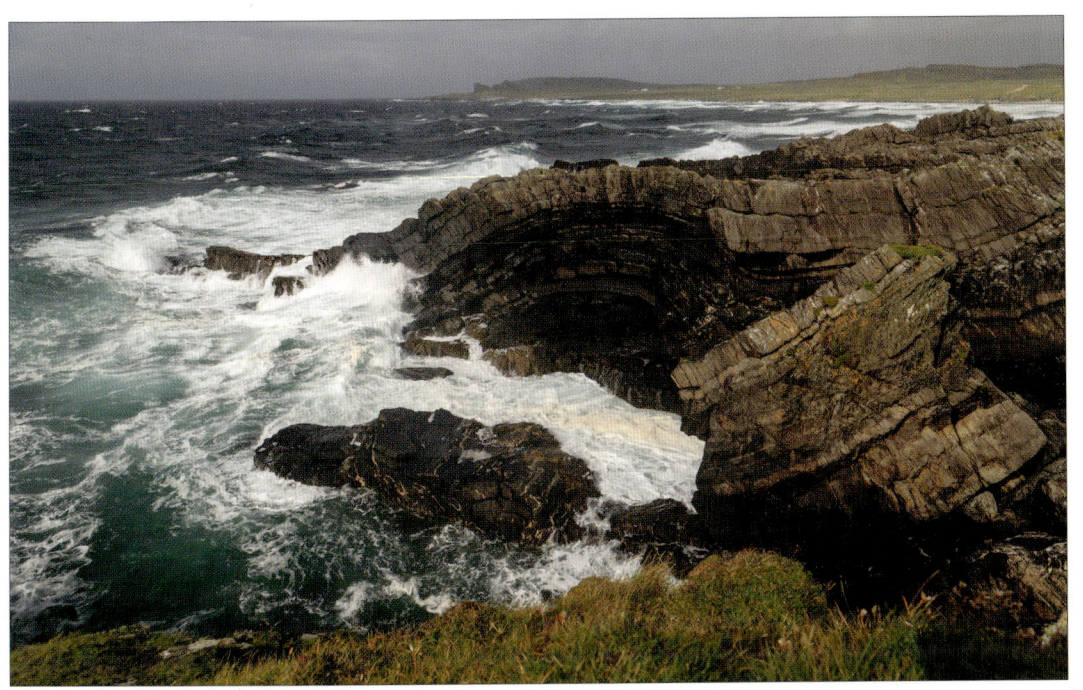

... while on a very different kind of day at Saligo, big seas batter the dramatically contorted rock formations to be found on this stretch of the Islay coast.

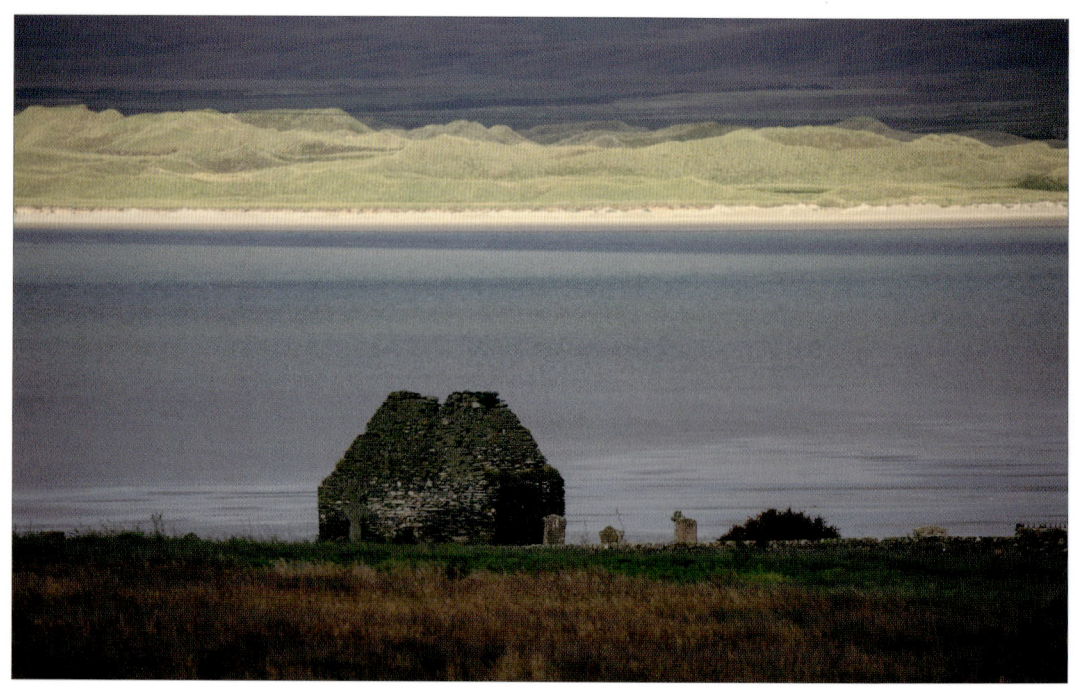

30 A few miles to the east, a view from the Ardnave road shows Kilnave Chapel swallowed up by the advancing evening while across Loch Gruinart sunlight pours brightly upon the dunes.

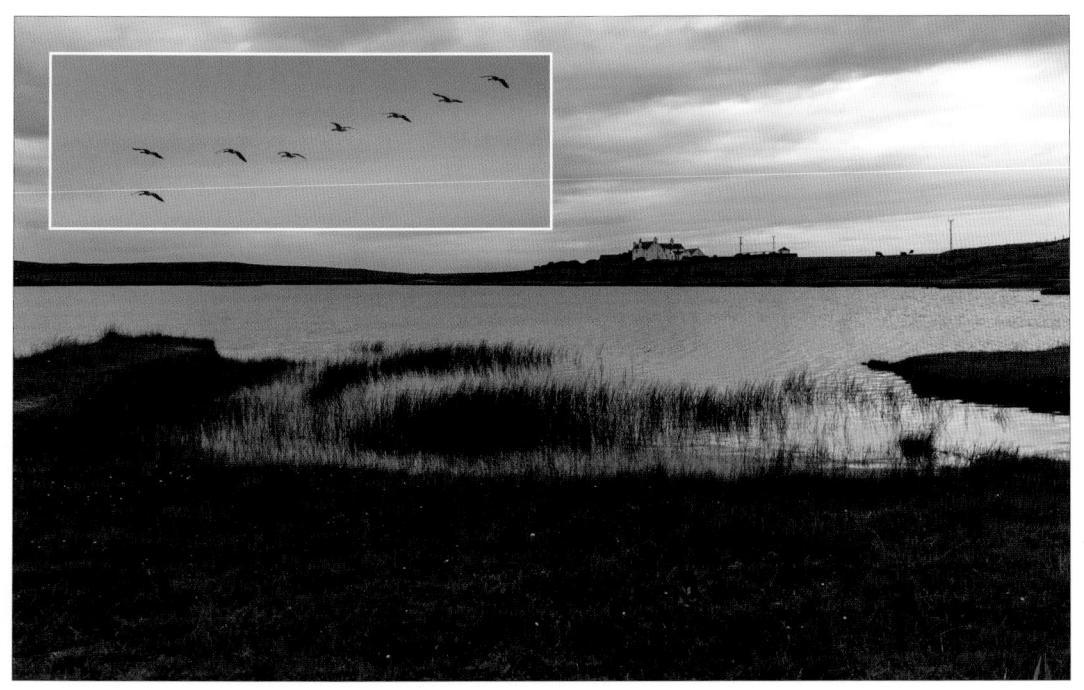

Main picture: as the evening draws on, serene low light gives an air of tranquillity to Ardnave Loch. This loch contains a crannog. Above: geese flying over the loch.

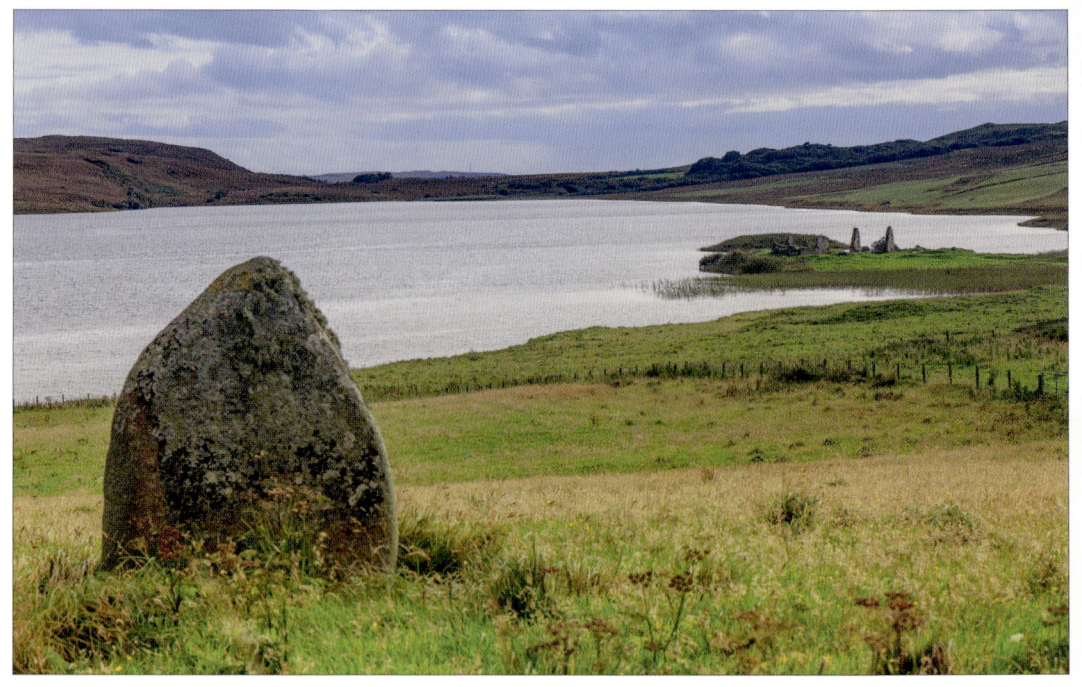

32 The medieval ruins at Finlaggan, at one time the main centre of power for the Lordship of the Isles, stand on an island in the beautiful secluded Loch Finlaggan in the north-east of Islay.

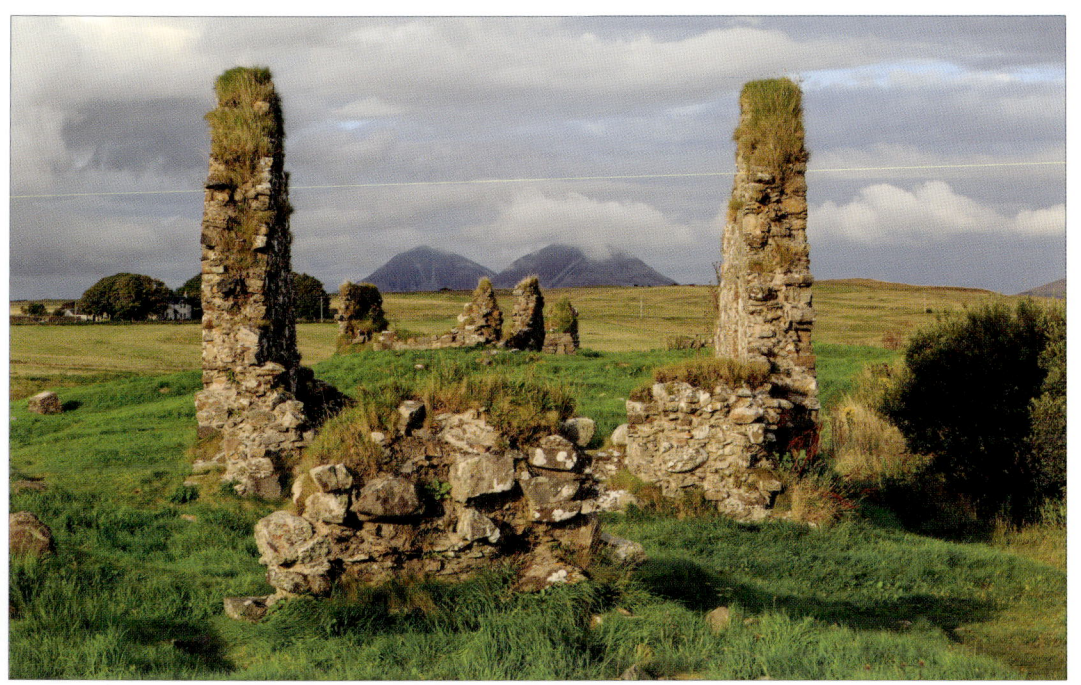

A view through the remains of the Great Hall at Finlaggan to the ruins of the 14th-century chapel, which also frames the Paps of Jura in the distance. At its peak there were over 20 buildings here.

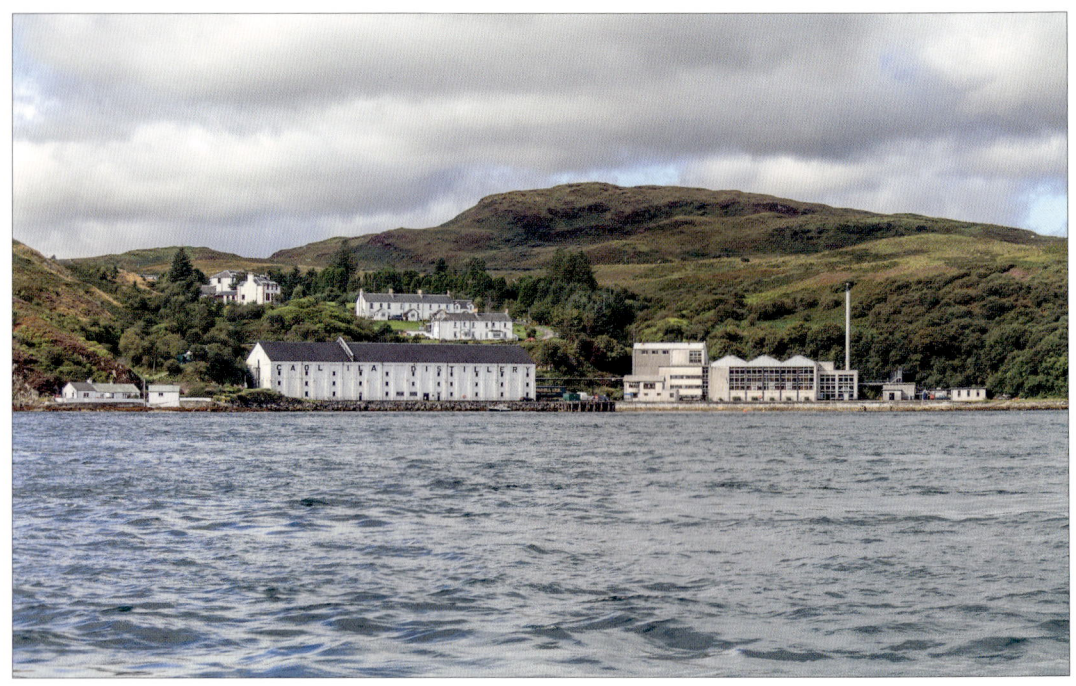

34 Located close to Port Askaig, Caol Ila (pronounced Cull Eela) is the largest distillery on Islay. For almost 100 years the whisky was taken by ship directly from the distillery to the mainland.

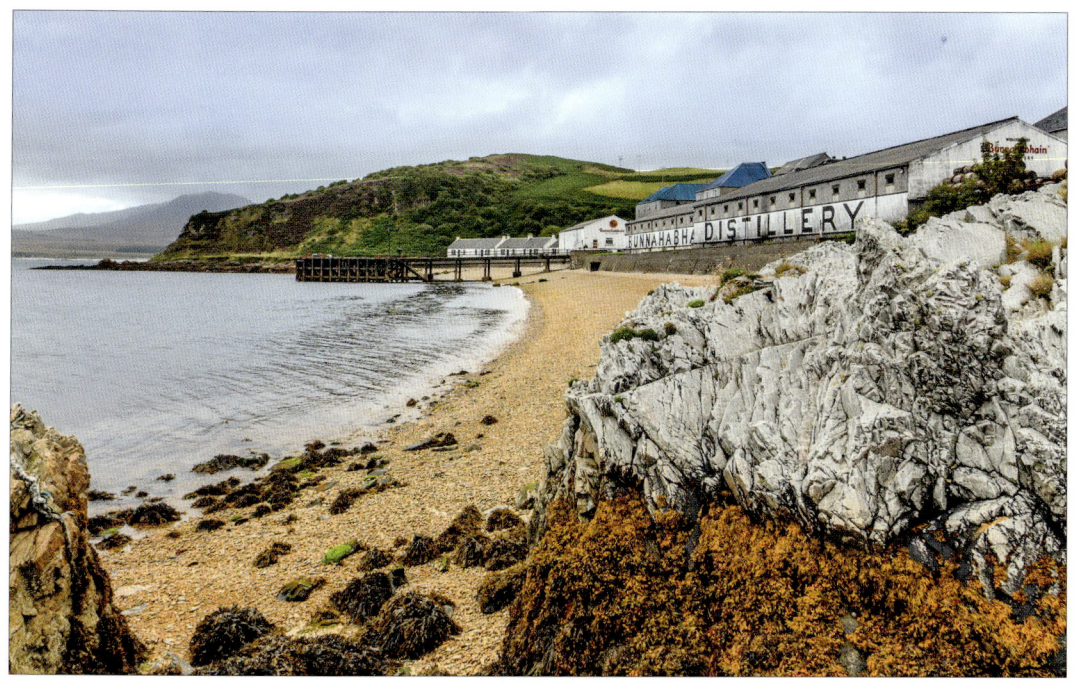

Built between 1881 and 1893 by the Greenlees brothers, Bunnahabhain Distillery is located at the northern end of Islay. Unlike many of the Islay distilleries, its whisky does not have a hugely peaty aroma.

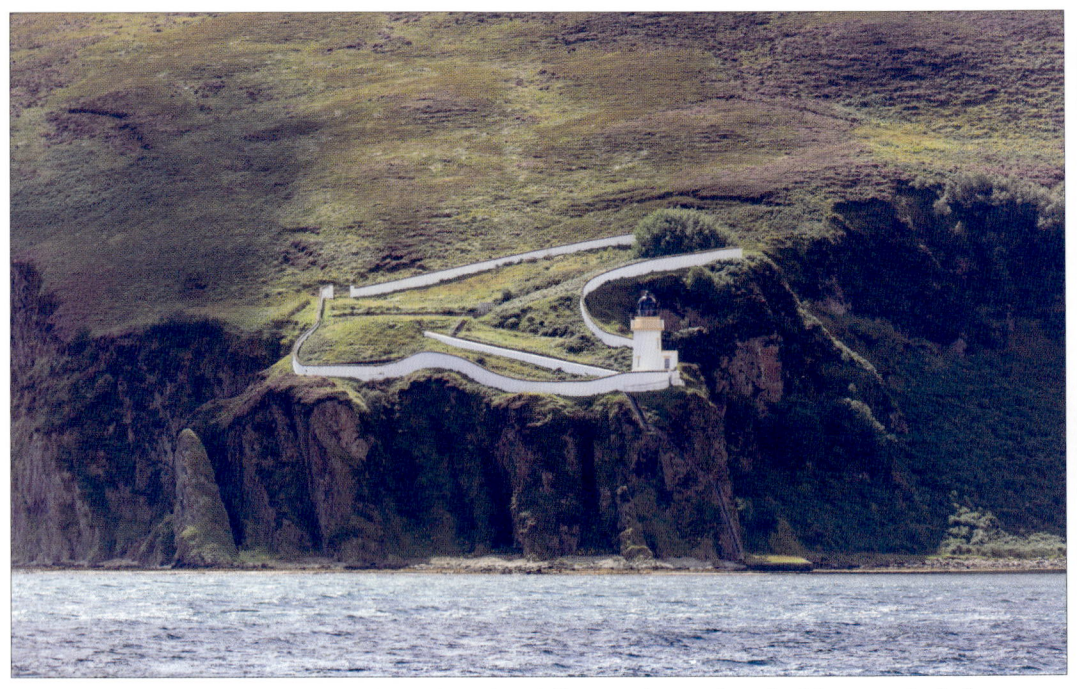

36 MacArthur's Head Lightouse is located on this cliff-top at the south end of the Sound of Islay. Its white-walled compound snakes around the hillside. Just visible is the ladder from the shore.

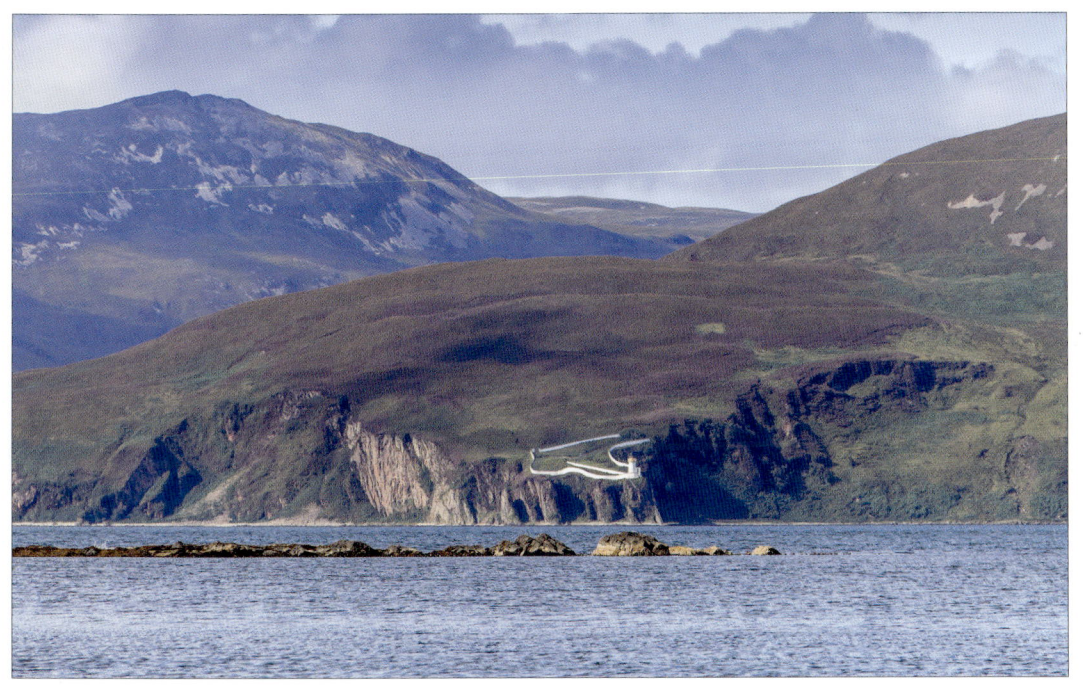

In this wider view, the remoteness of the lighthouse's location can be better appreciated. The hill in the background is Beinn Bheigier which, at 491m/1610ft, is the highest point on Islay.

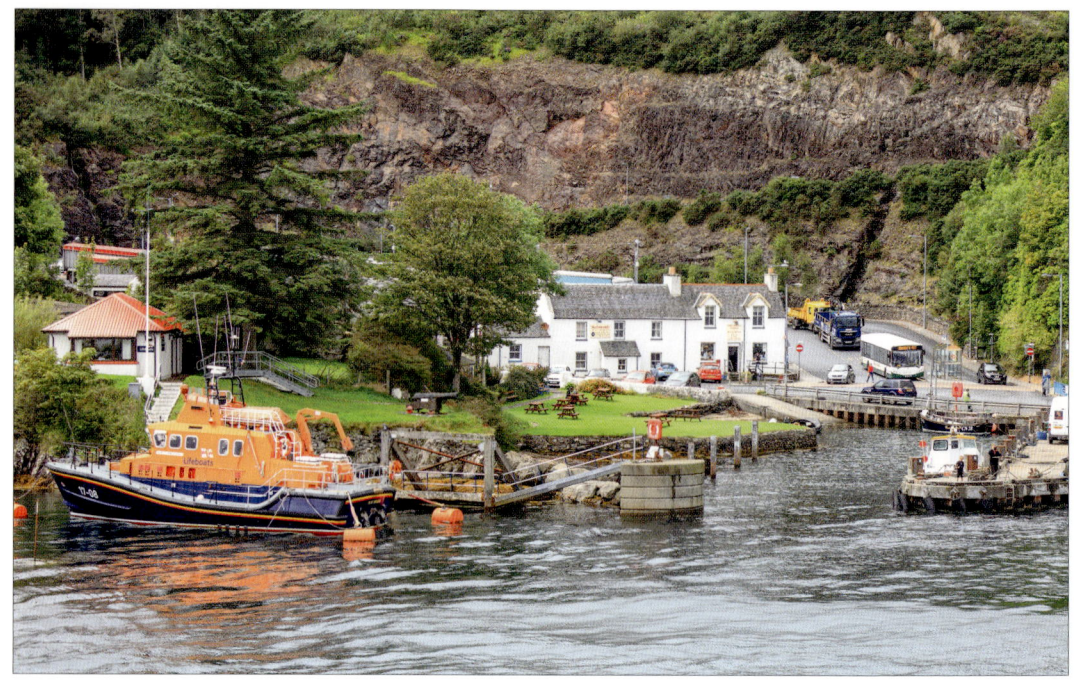

38 Our journey around Islay ends at Port Askaig in the north-east of the island. Although it is tucked in under steep cliffs, it contains a hotel, shop and Post Office, as well as providing port services for

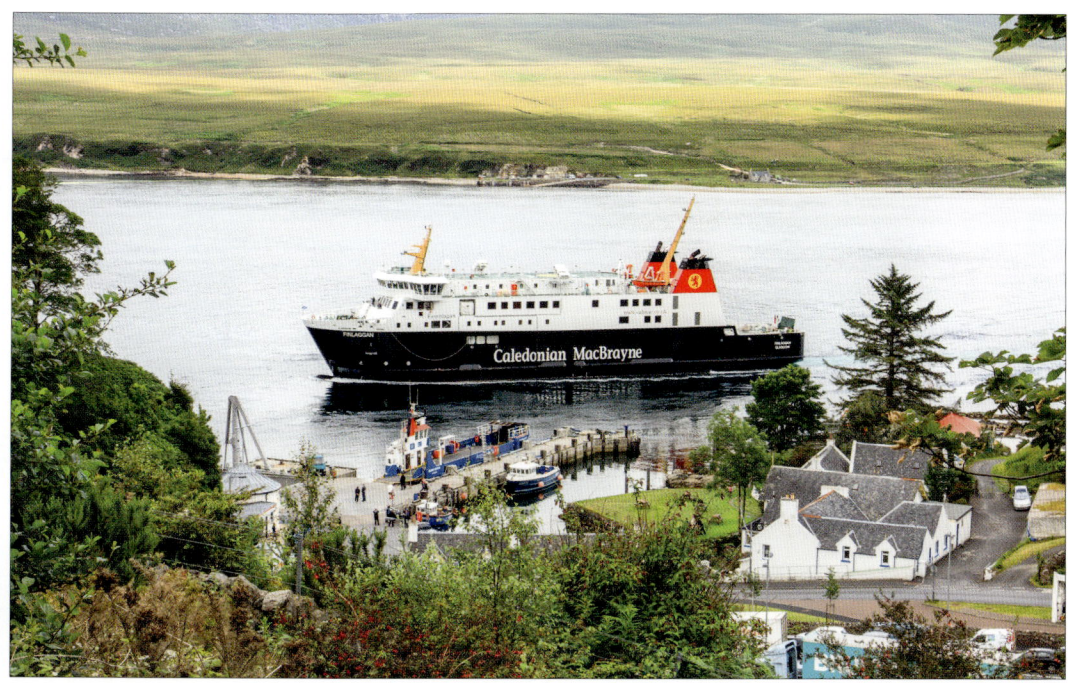

ferries to both the mainland and Jura. Here, MV *Finlaggan* arrives from Kennacraig, dwarfing the Jura ferry which is berthed in front of her.

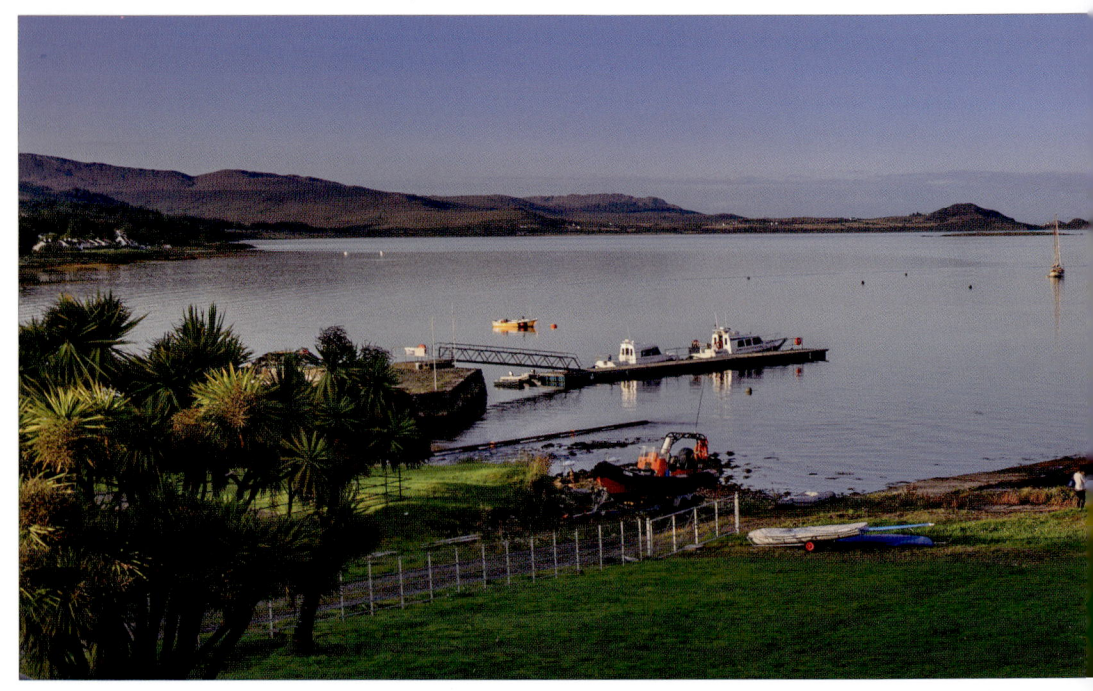

40 Craighouse is Jura's only village and enjoys an enviable location on the shores of a secluded bay which, in turn, is part of the larger Small Islands Bay. Some of those little islands can be seen in this

picture taken from the Jura Hotel. The bay has a goodly number of moorings. A seasonal foot ferry sails from Craighouse to Tayvallich on the Argyll mainland.

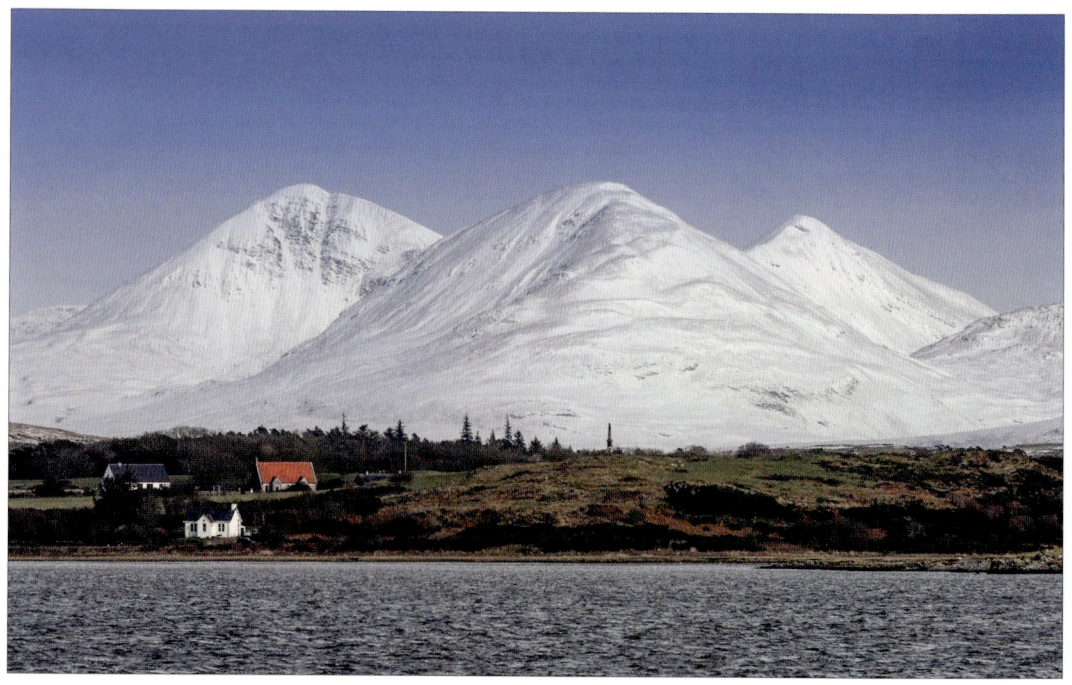

42 The classic winter view of Jura with the Paps looking inviting and intimidating in equal measure thanks to a hefty covering of snow.

Left: the small ferry has to cope with strong currents during the short crossing of the Sound of Islay to Jura. Right: nature's pyrotechnics provide this partial rainbow over the same stretch of water.

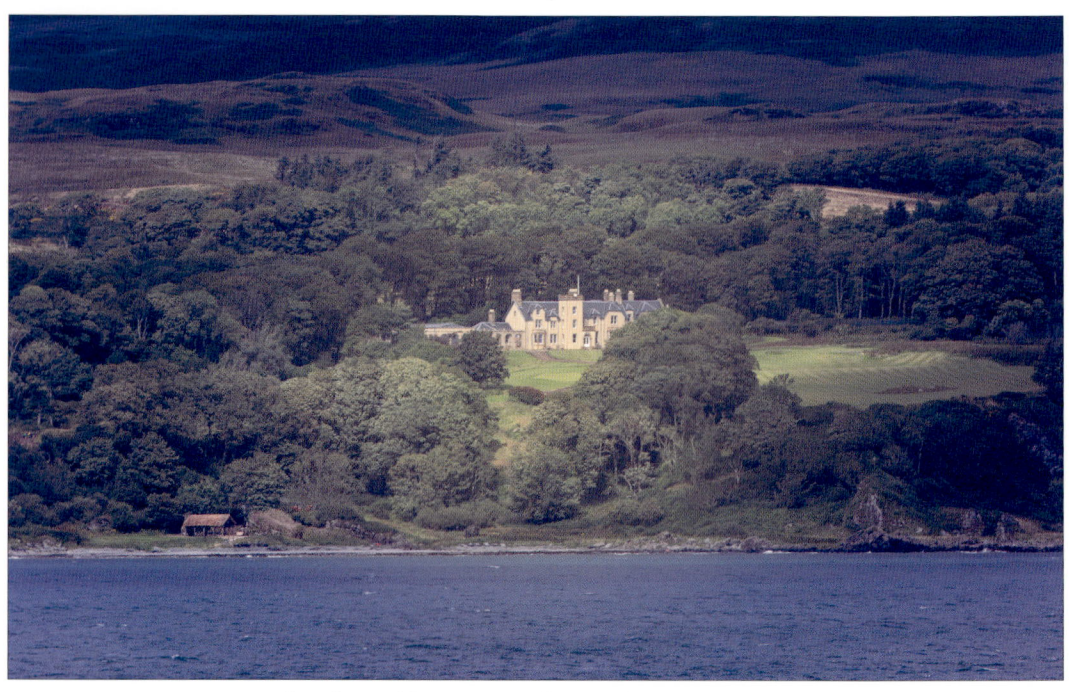

44 Jura House is positioned in the Ardfin Estate on the southern tip of Jura. At the time of writing it is being converted into a luxury hotel complete with world-class 18-hole golf course.

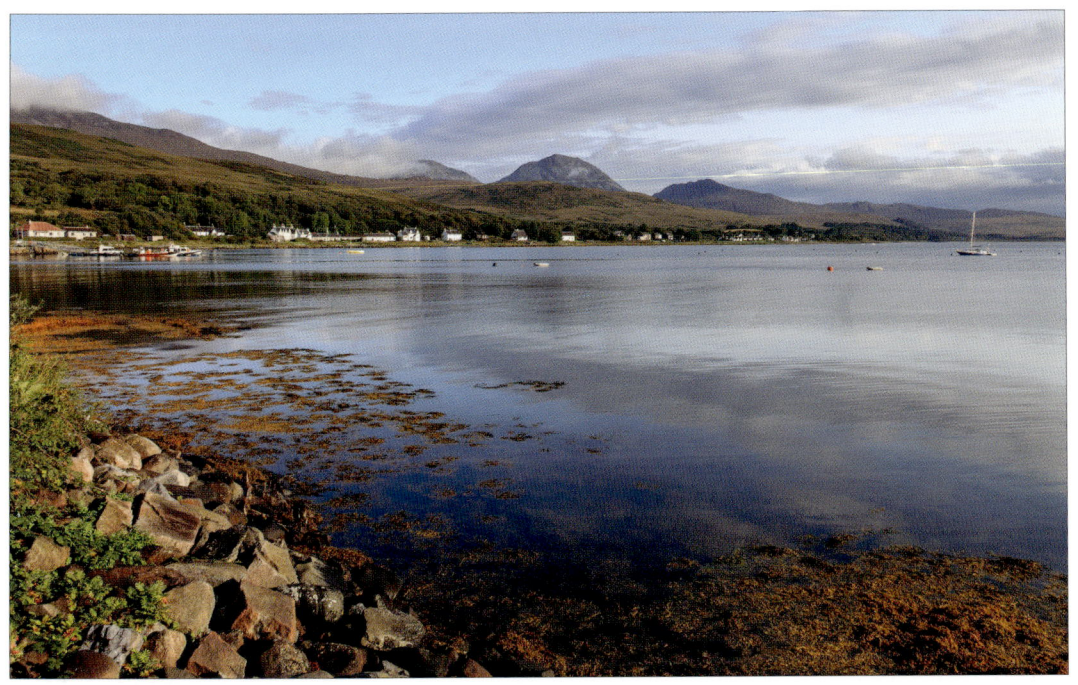

Craighouse Bay is one of those places where it is blissful simply to sit and watch and pass the time.
On the horizon, Beinn Shiantaidh suggests a more vigorous alternative!

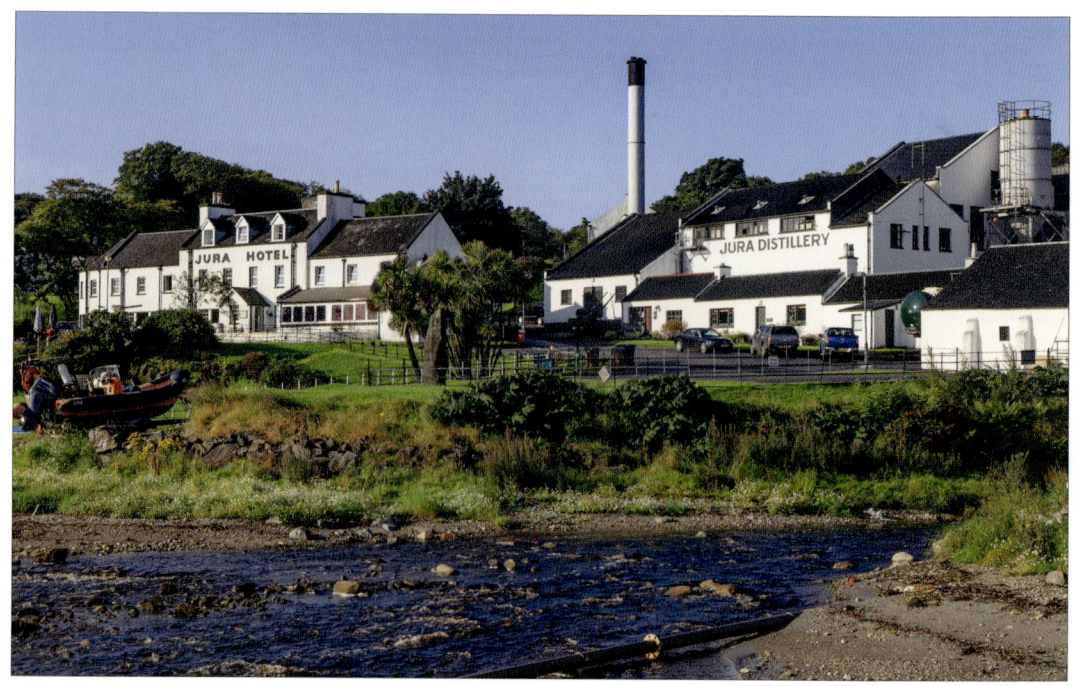

46 The Jura Hotel and Jura Distillery sit side by side in Craighouse. The distillery was established in 1810 and reconstructed in 1963. It is open most of the year for tours and tastings.

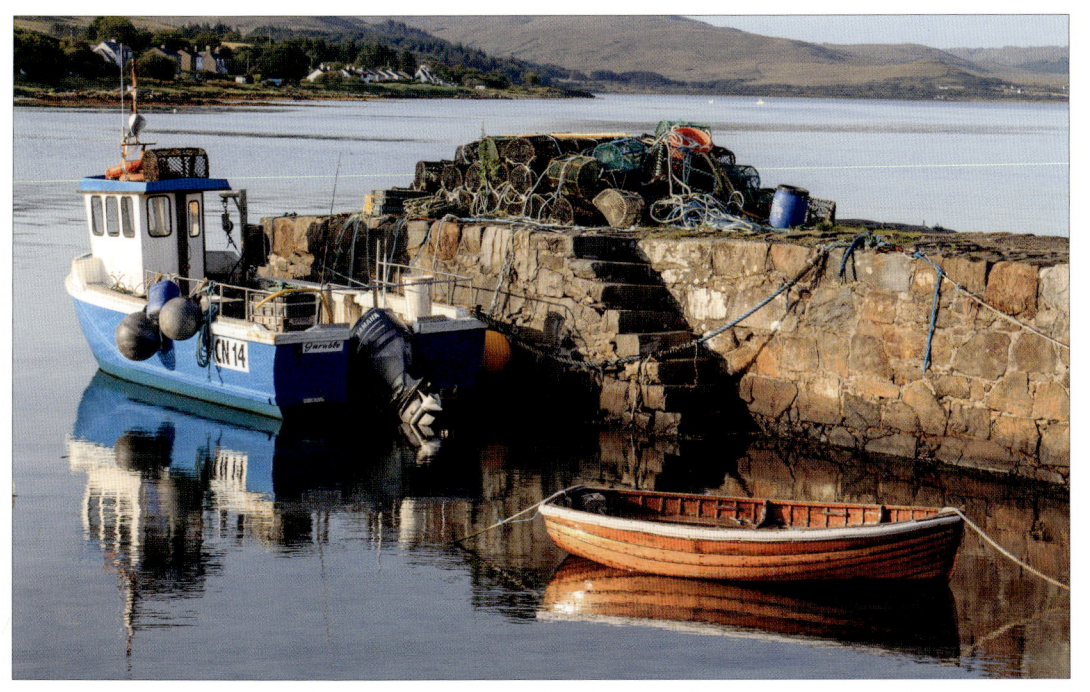

Evening tranquillity at Craighouse jetty: boats gently reflecting in home waters – an enduring scene that never grows 'old'.

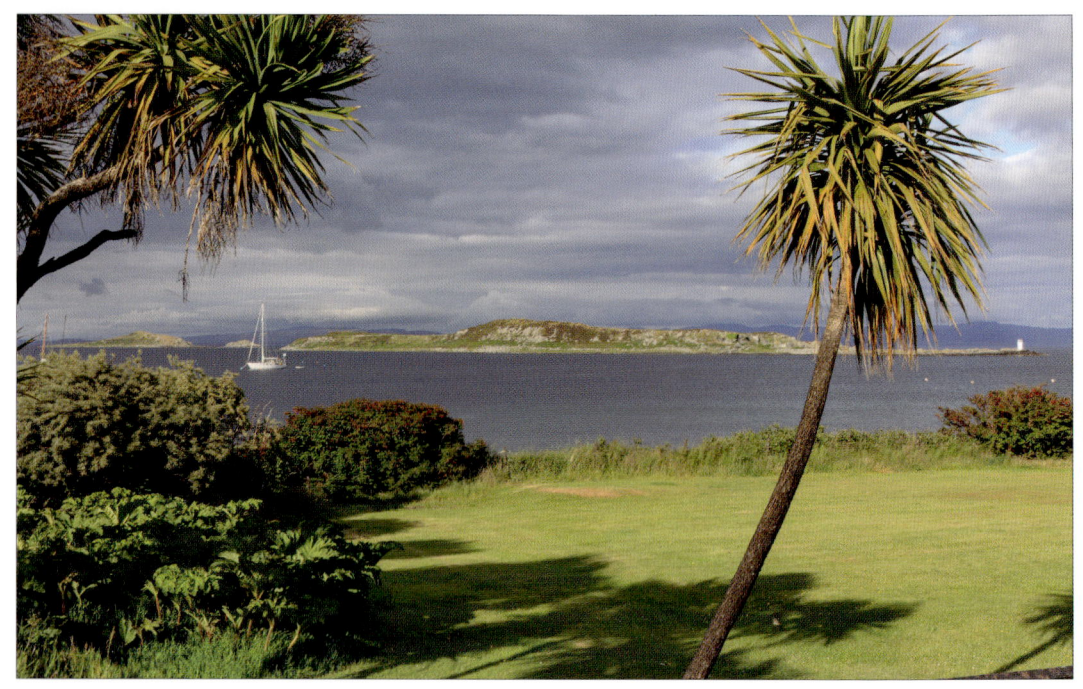

48 The sheltered eastern coast of Jura generally enjoys a mild climate, and palm trees grow, adding an unexpectedly tropical touch.

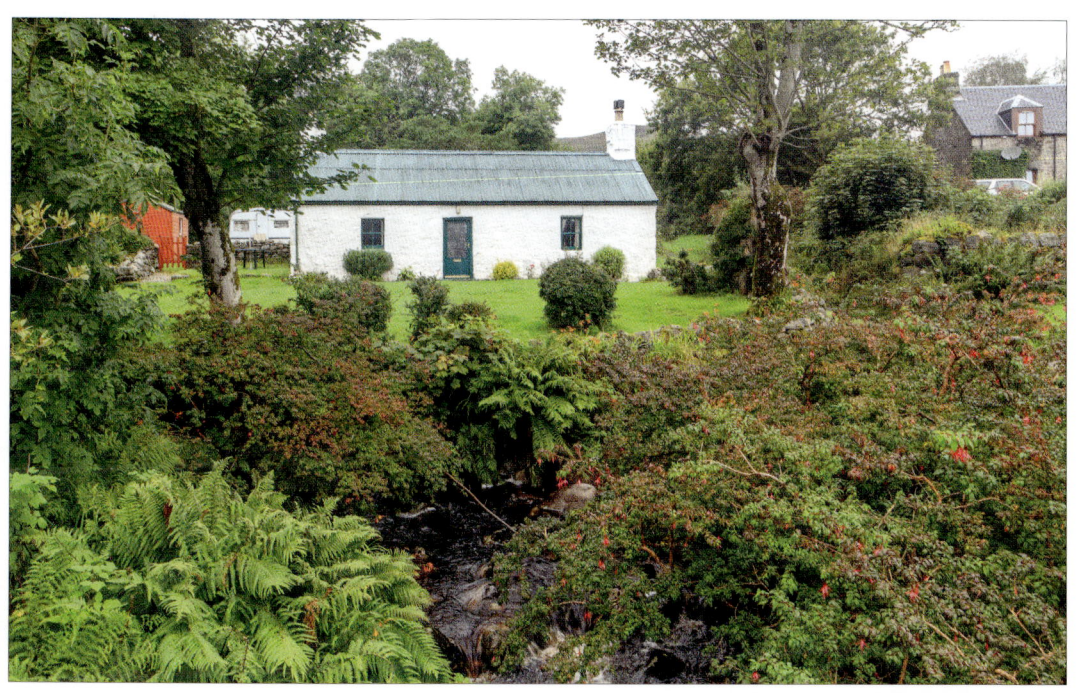
An example of the 'but and ben' type of cottage at Keills just outside Craighouse. 'But and Ben' comes from the Scots language for a two-roomed dwelling.

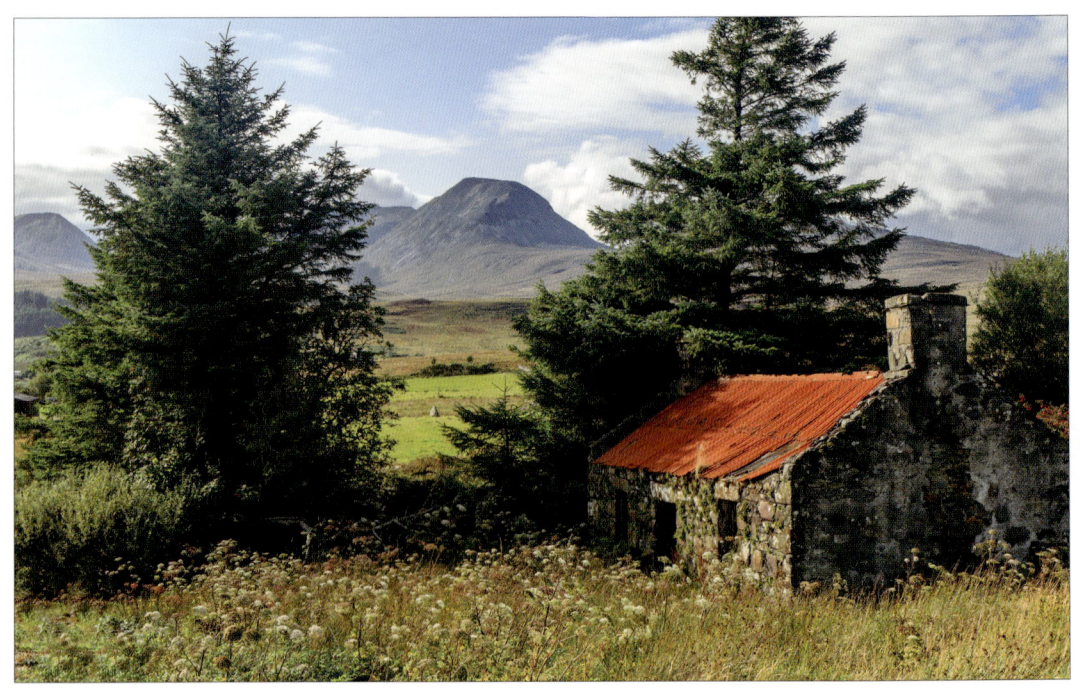

50 The hamlet of Ardfernal sits on a hillside above Loch na Mile to the north of Craighouse, one of those places where sleeping ruins testify to past times of greater population.

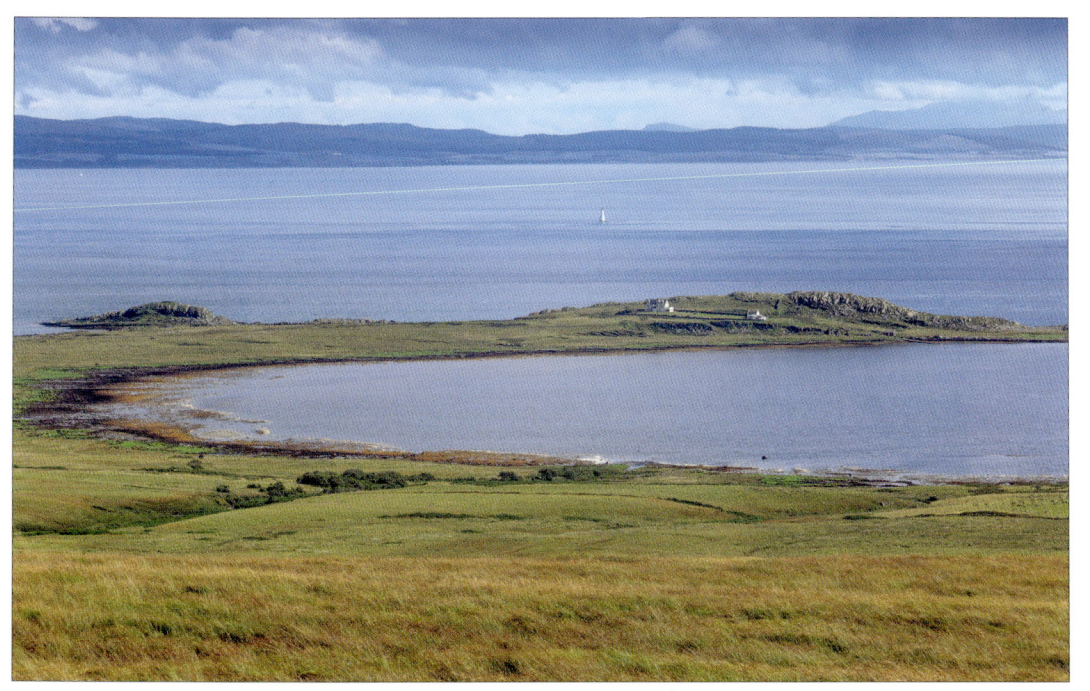

Just north of Ardfernal is the great sweep of Lowlandman's Bay. Its name refers to traders from south-west Scotland (the Lowlands) who set up temporary trading posts there.

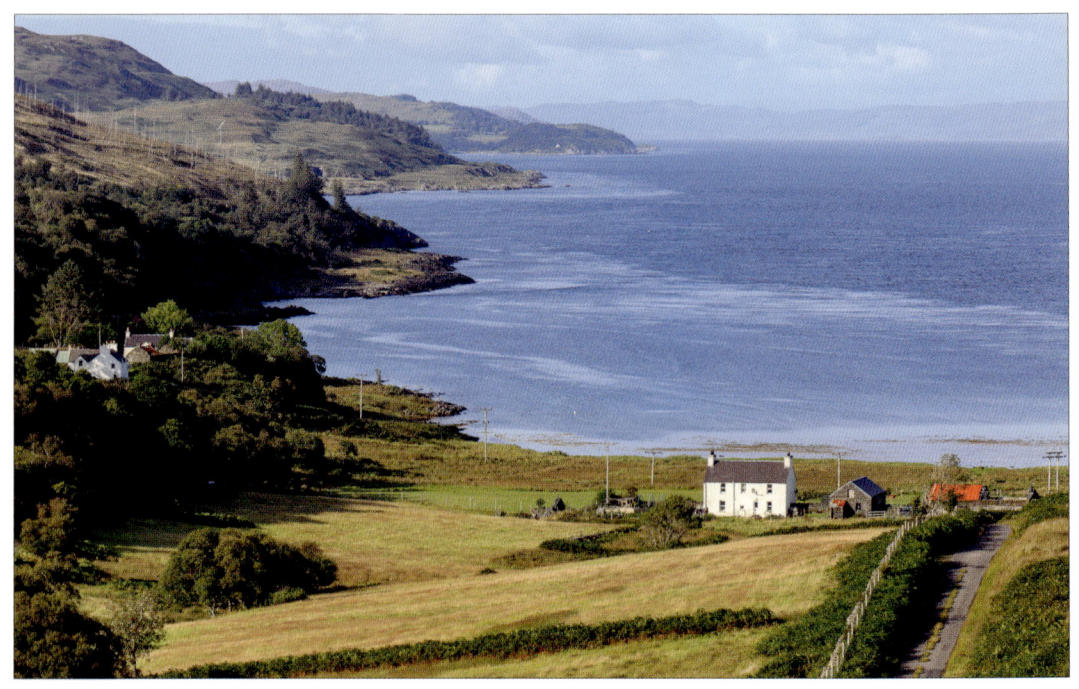

52 Continuing north up Jura's east coast, the view from a high point above the hamlet of Lagg (meaning 'hollow') reveals a series of bays and their intervening promontories ('ards') stretching to the horizon.

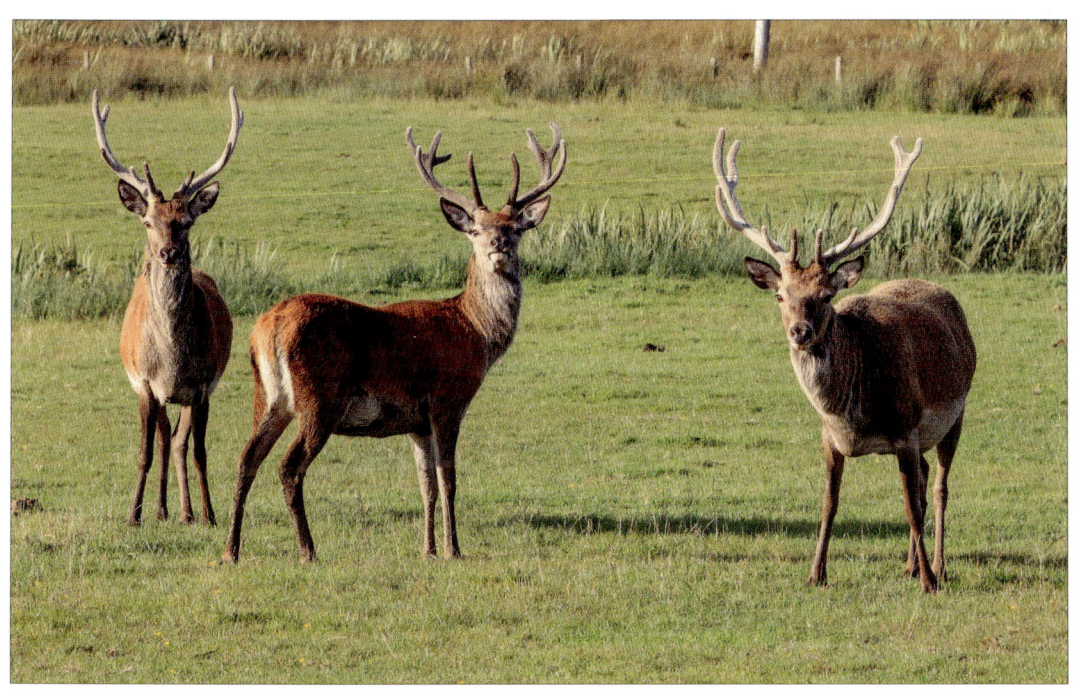

Jura is home to more than 5,000 deer. These handsome red deer stags were grazing in a fertile field in Lagg.

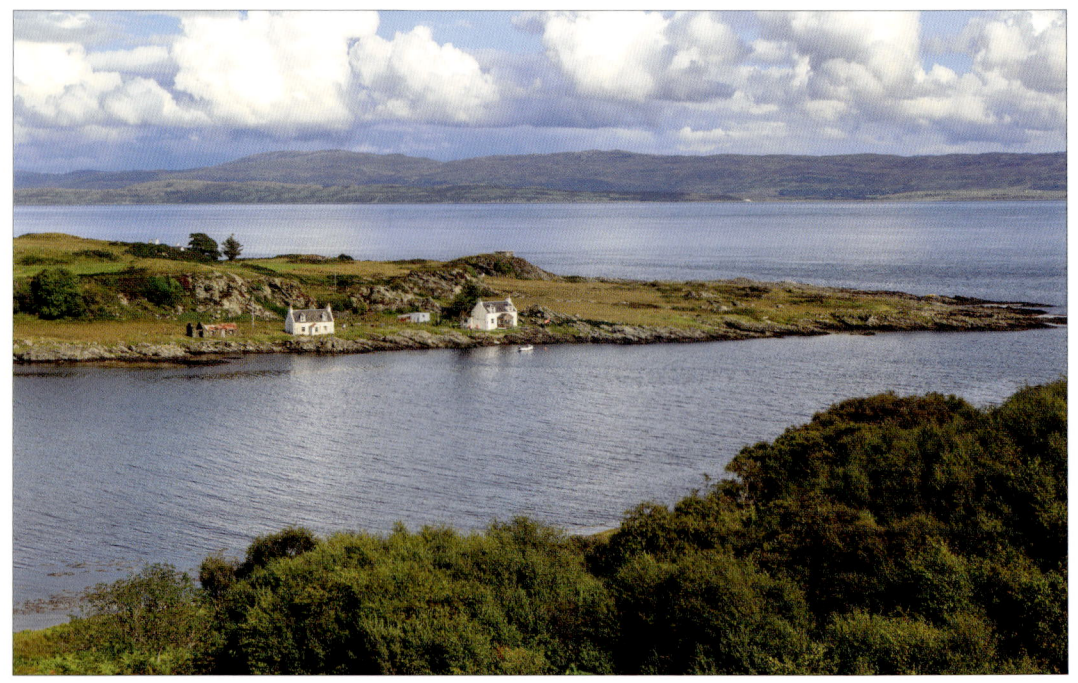

54 Here we see the eastern part of Loch Tarbert. 'Tarbert' is a Norse word for a place where boats can be dragged over a low place between two areas of water – see also pages 56-57 and 65.

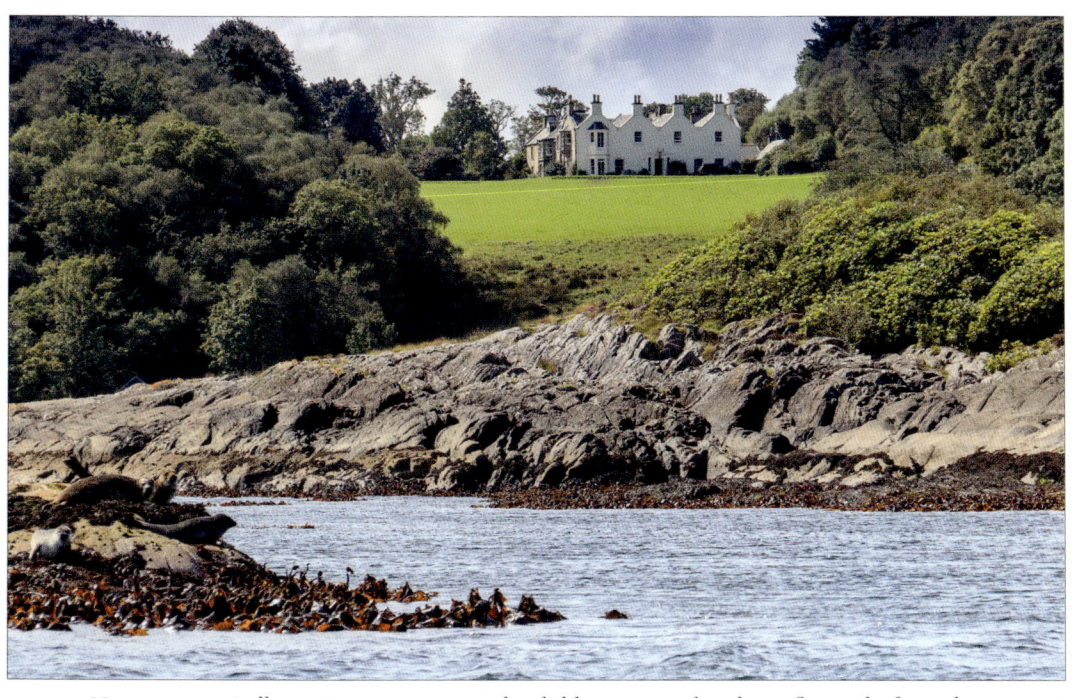

Victorian-era Ardlussa House enjoys a splendid location and makes a fine sight from the sea, complete with a posse of seals on the rocks below.

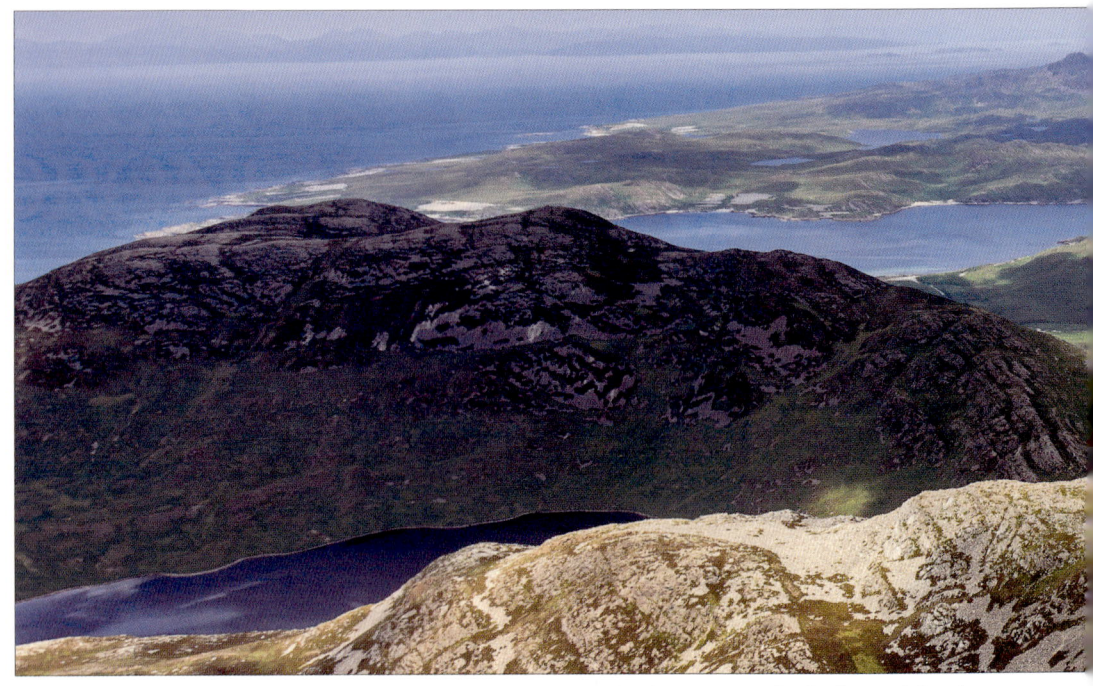

56 A visit to Jura is greatly enhanced by an exploration of the three Paps. The highest of the three is Beinn an Oir, the Mountain of Gold, which reaches 785m/2576ft. This is the magnificent view from

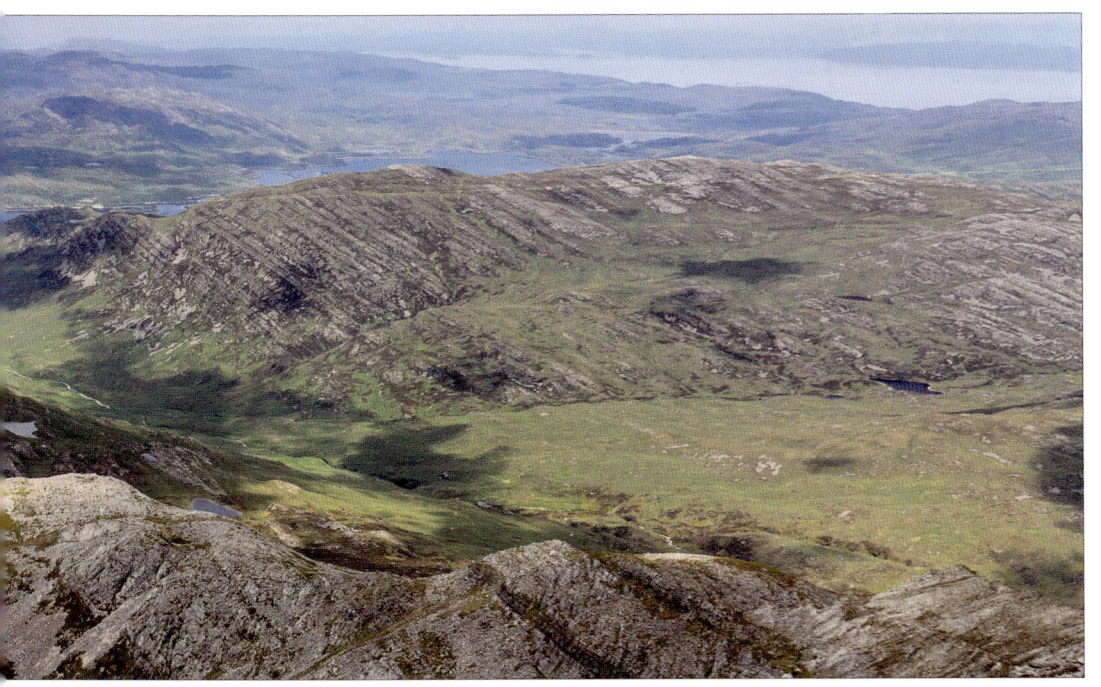

its summit, looking north over Jura's wilderness. Loch Tarbert can be seen encroaching most of the way across the island in the middle distance.

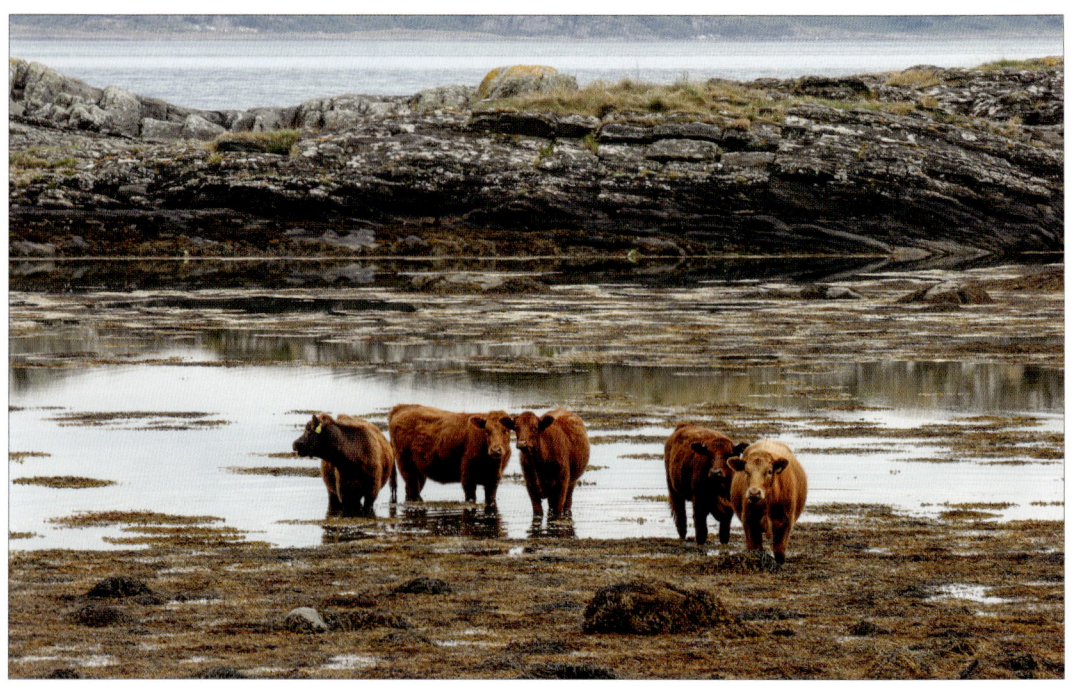

58 Returning to Lussa Bay, a tranquil scene where even the cattle know how to 'chill out' and enjoy the sea.

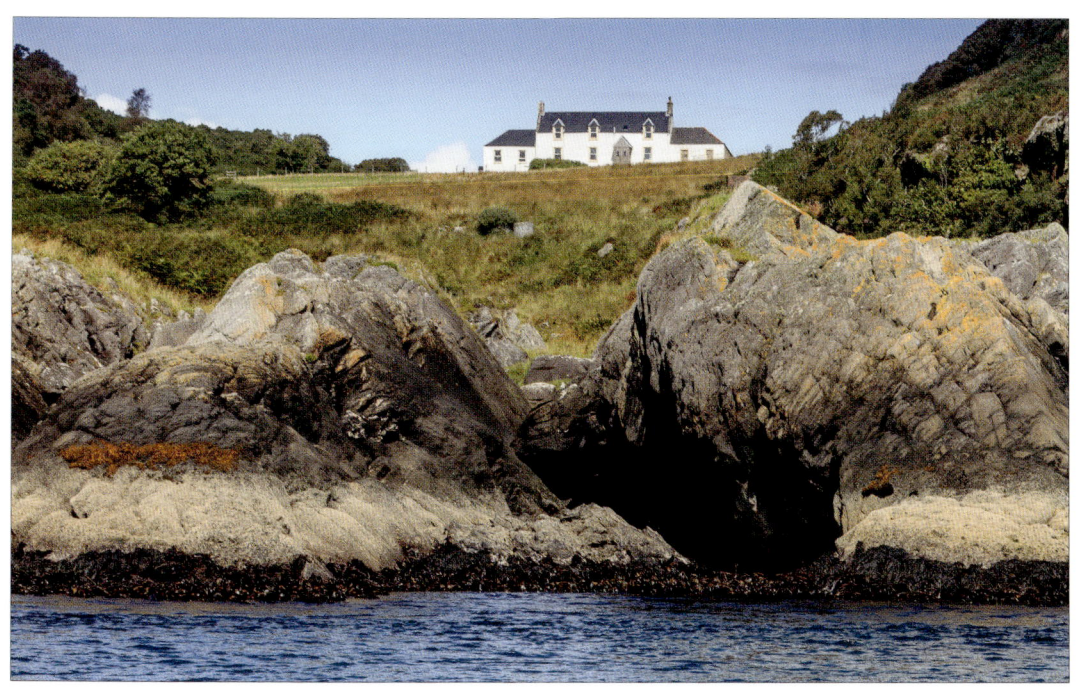

Seen here from the sea, Barnhill, near the northern tip of Jura, where George Orwell lived from 1946-48 while writing his novel *1984*.

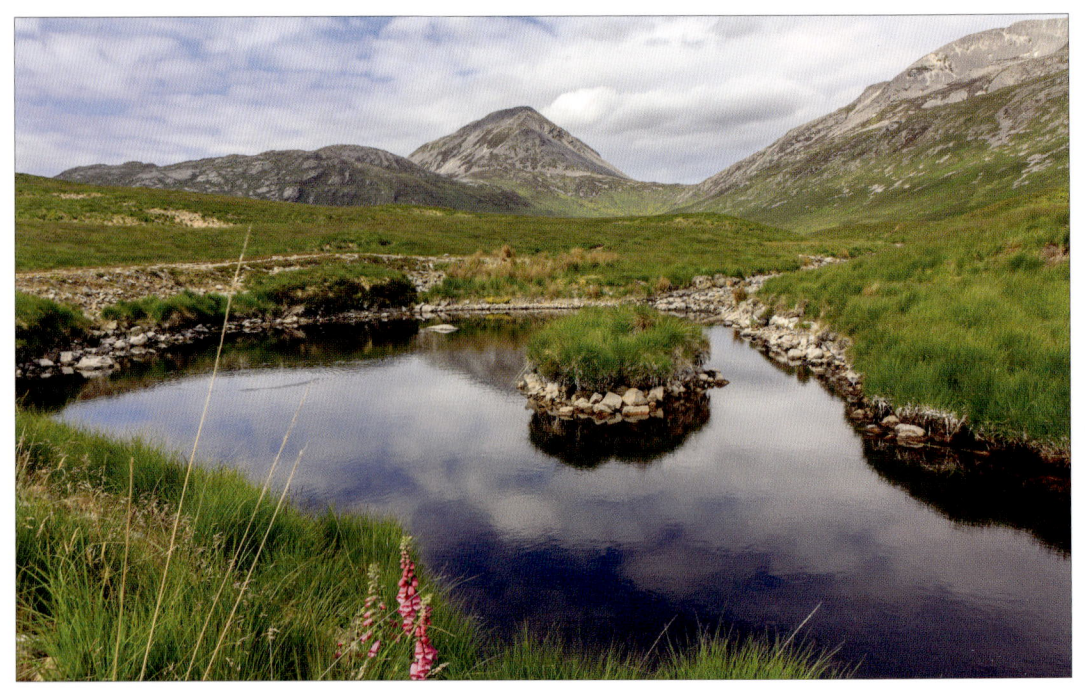

60 All three Paps can be climbed in one arduous walk. Here, ahead is Beinn a' Chaolais, at 734m/2407ft the third highest of the three main peaks. Beinn an Oir is on the right.

Left: Beinn Shiantaidh, the Sacred Mountain, is second highest at 757m/2477ft.
Right: if heading directly for Beinn an Oir, the route goes up by this stream – follow the foxgloves!

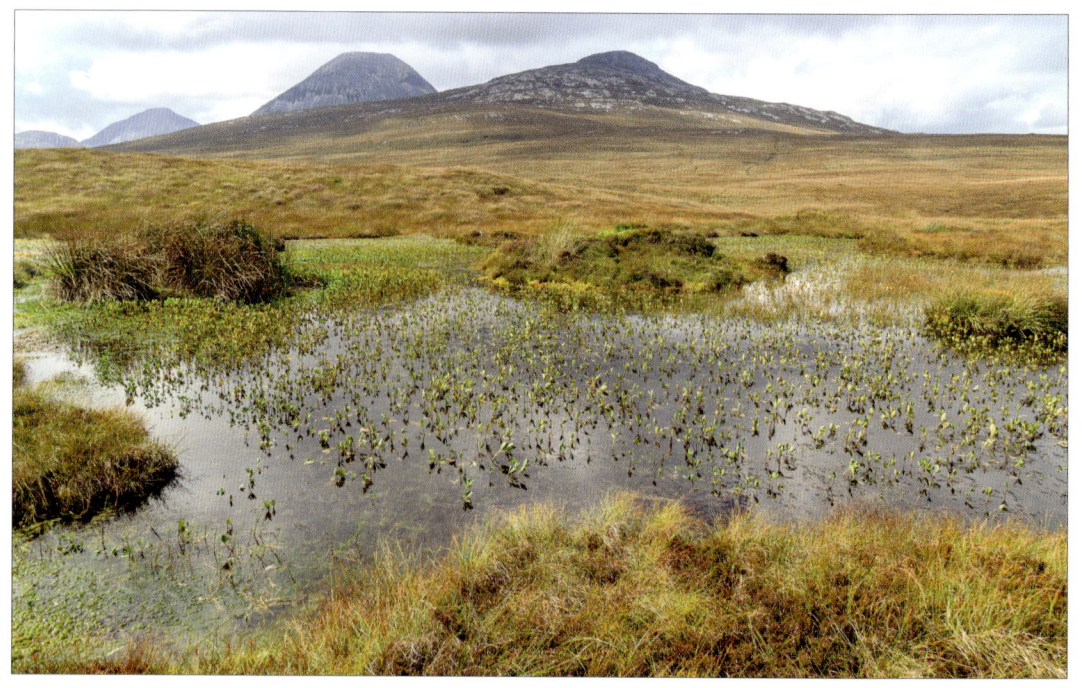

62 A longer, though less hilly, adventure is the 11-mile out-and-back Evans' Walk from east to west across Jura to Glen Batrick Bay. This can be a very boggy affair, encountering terrain like this.

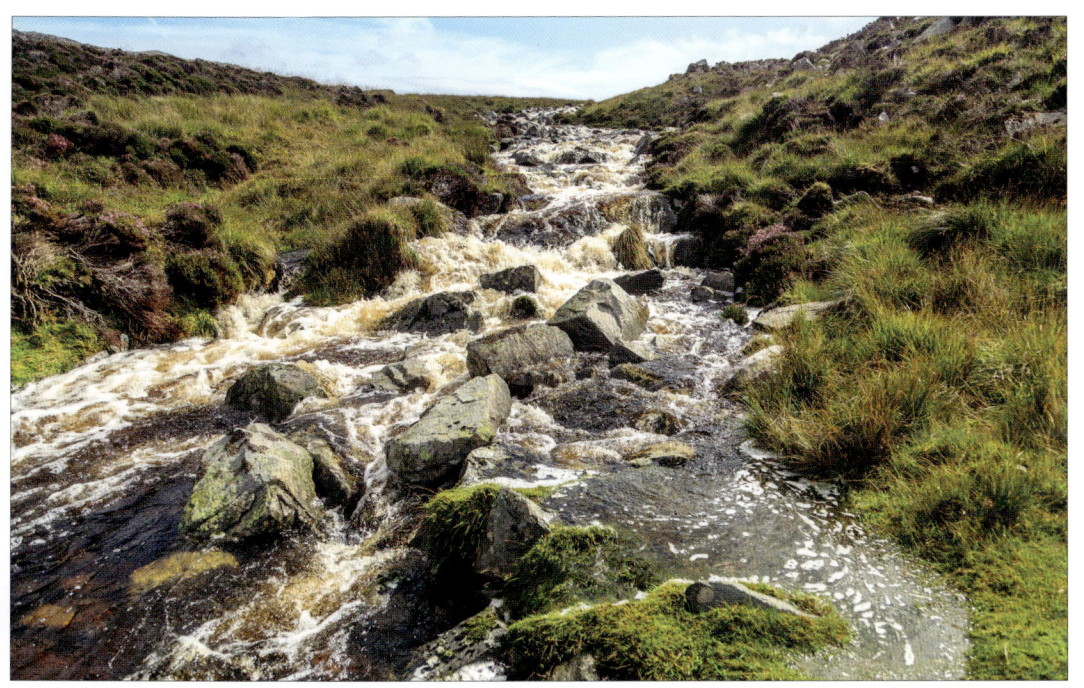

Further along Evans' Walk, on the descent towards Glen Batrick, Abhainn Loch na Fudarlaich tumbles down several cascades like this en route to the western seaboard of Jura.

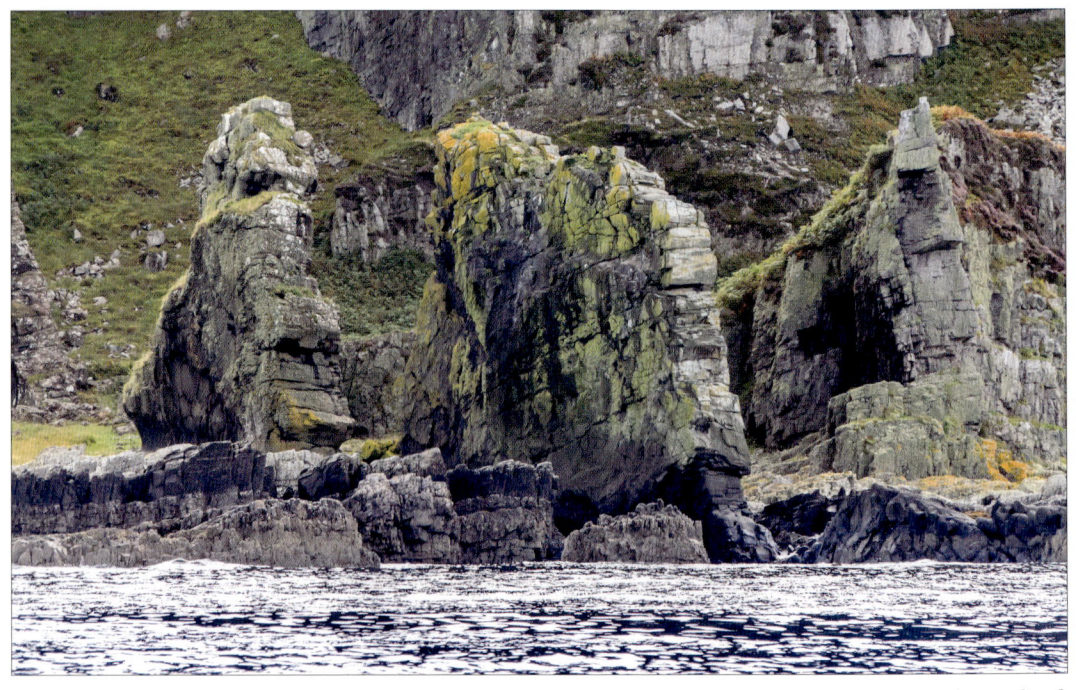

64　Taking the round-Jura boat trip is the best way to appreciate the extraordinary coastline of the island. These vertical slices of rock on the west coast remain where softer rocks between are long gone.

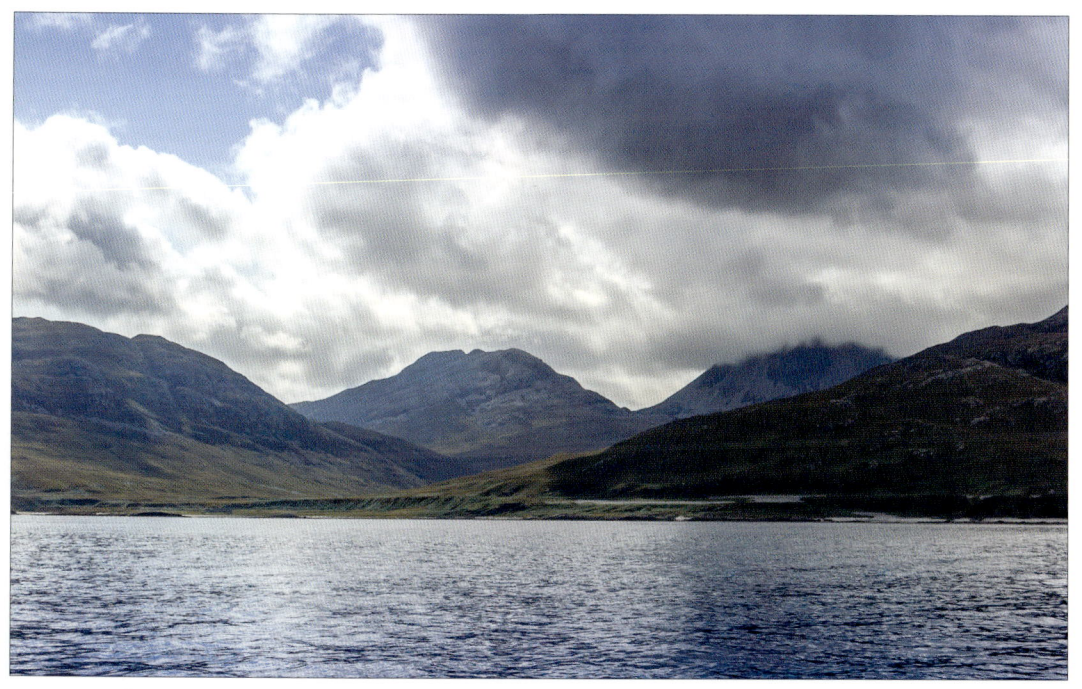

From the entrance to Loch Tarbert, the view up Glen Batrick, with Corra Bheinn (573m/1879ft) centre stage. Evans' Walk terminates on these shores, where there are several areas of raised beach.

66 After periods of heavy rain, coastal waterfalls add to the drama by turning trickles into torrents that drop straight onto the beaches below. These two are on Jura's west coast north of Loch Tarbert.

Above: another coastal curiosity is the sight of this type of seaweed which stands up well above the water. Below: the sea boils with leaping fish! The cause of the disturbance was not seen . . .

The sea between the north of Jura and the neighbouring island of Scarba is known as the Gulf of Corryvreckan. Here, the combination of a deep, 219m/718ft trench in the sea floor which is confronted by an underwater rock pinnacle that rises to 29m/95ft below the surface creates tidal flows, up-thrusts and whirlpools. When strong westerly winds are added, the up-thrusts meet incoming waves to create standing waves that can reach a height of around 4m/13ft. Right: this prominent feature of waterfall and rock ridge on Jura marks where this phenomenon occurs. Opposite: a standing wave with Jura in the background.

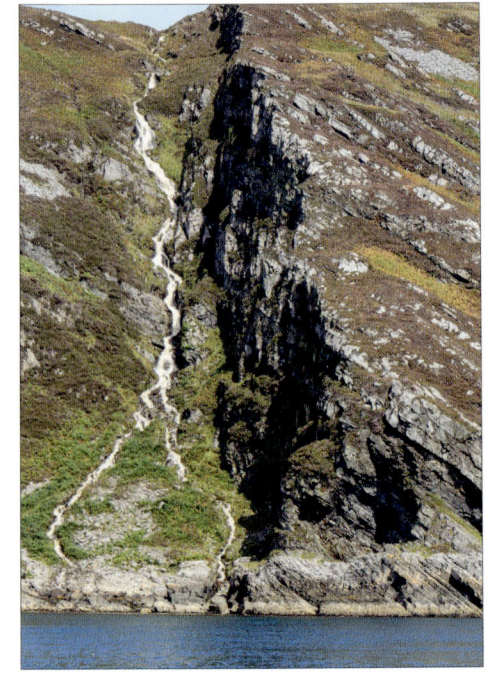

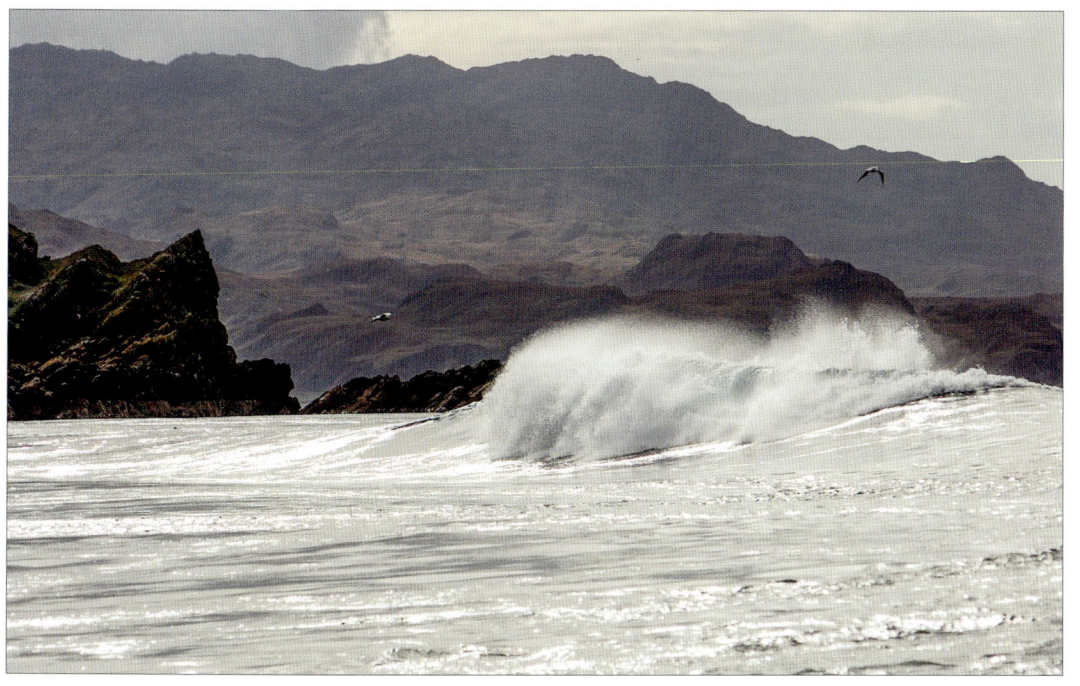

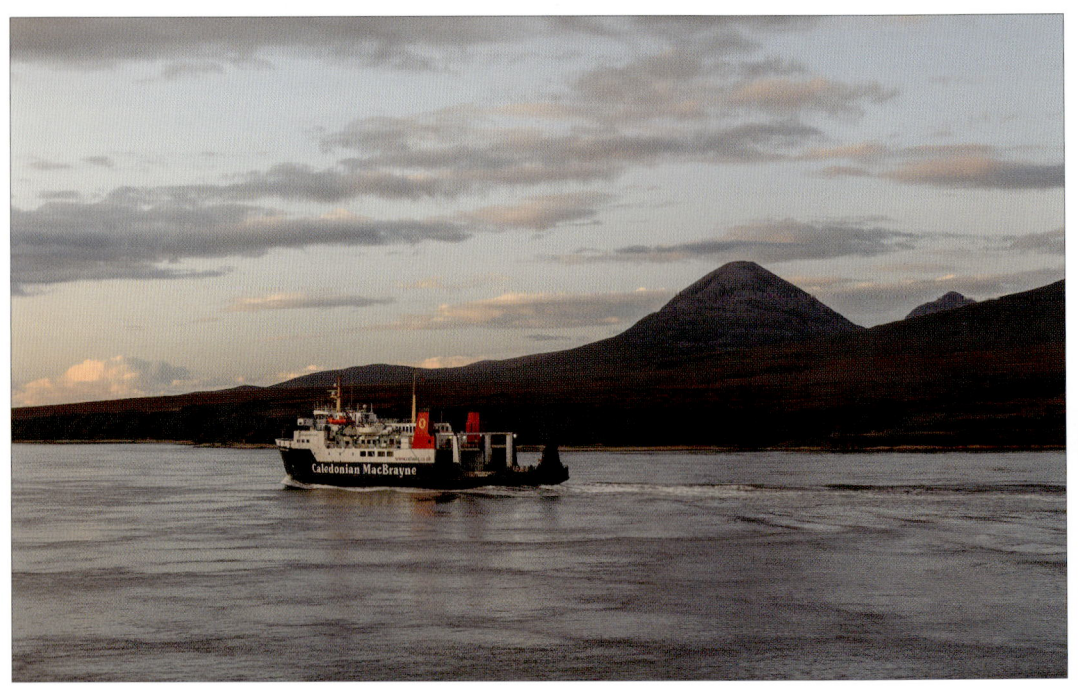

70 Now it's time to take our leave of Jura and head for Colonsay. With two of the Paps silhouetted in the evening light, the ferry *Hebridean Isles* heads towards the open sea.

Left: another day, another ferry: MV *Clansman* backs on to the pier at Scalasaig. Colonsay is served by ferries from both Oban and Kennacraig. Right: Scalasaig War Memorial.

71

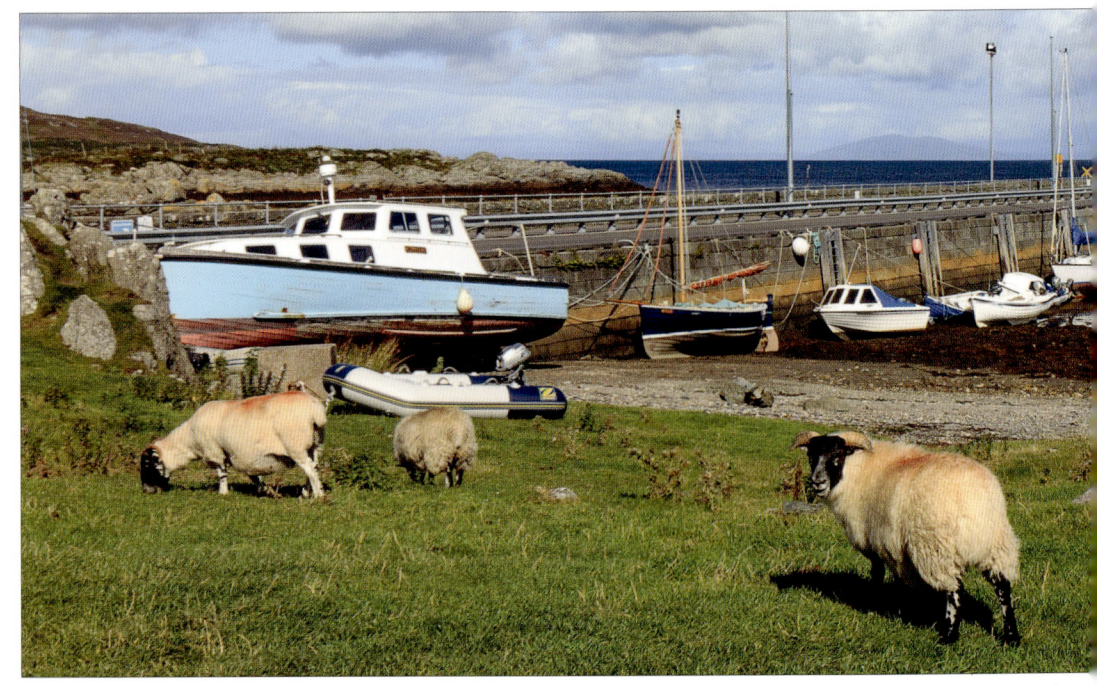

72 Scalasaig harbour typifies the informality of island life – no 'health and safety' barriers, the sheep roam and graze where they will. Most of Colonsay's amenities are found in Scalasaig – general store,

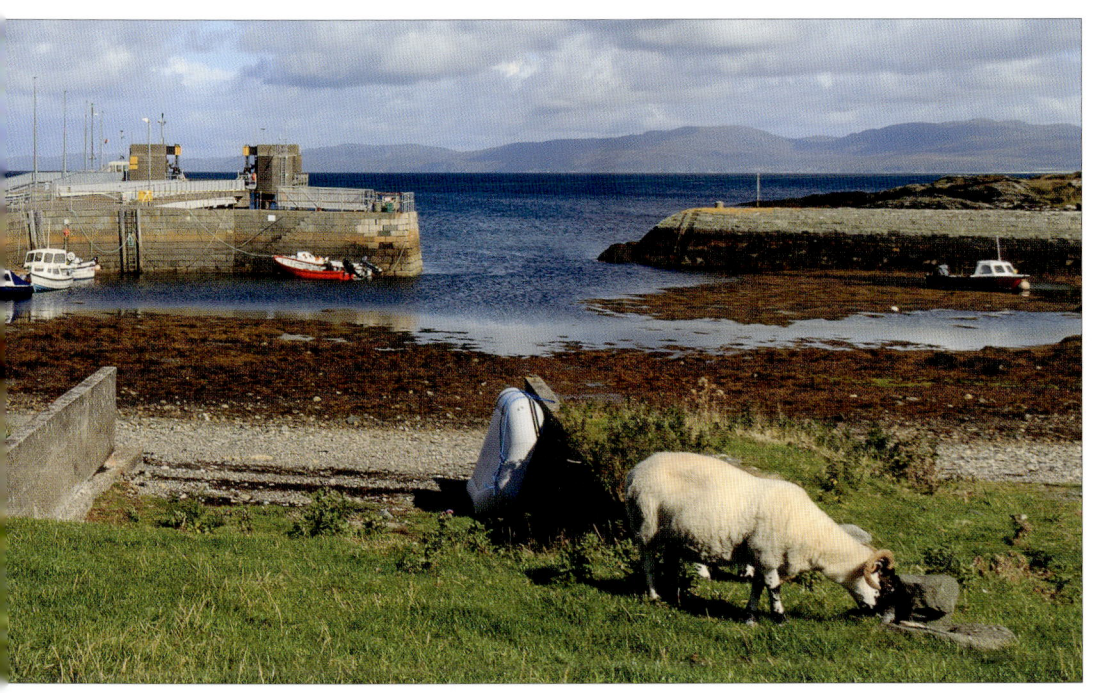

post office, two cafés, bookshop, church and hotel.

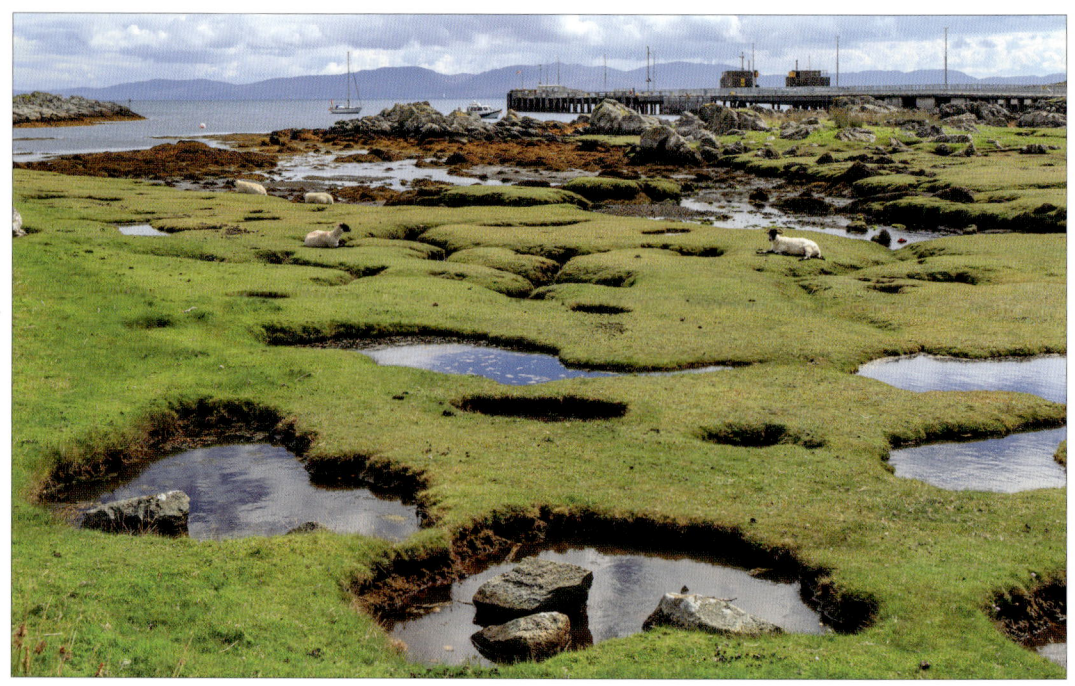

74 On the other side of the pier, these saltings are the buffer zone between land and sea, much enjoyed by more of the local sheep at low tide. The Isle of Mull can be seen in the distance.

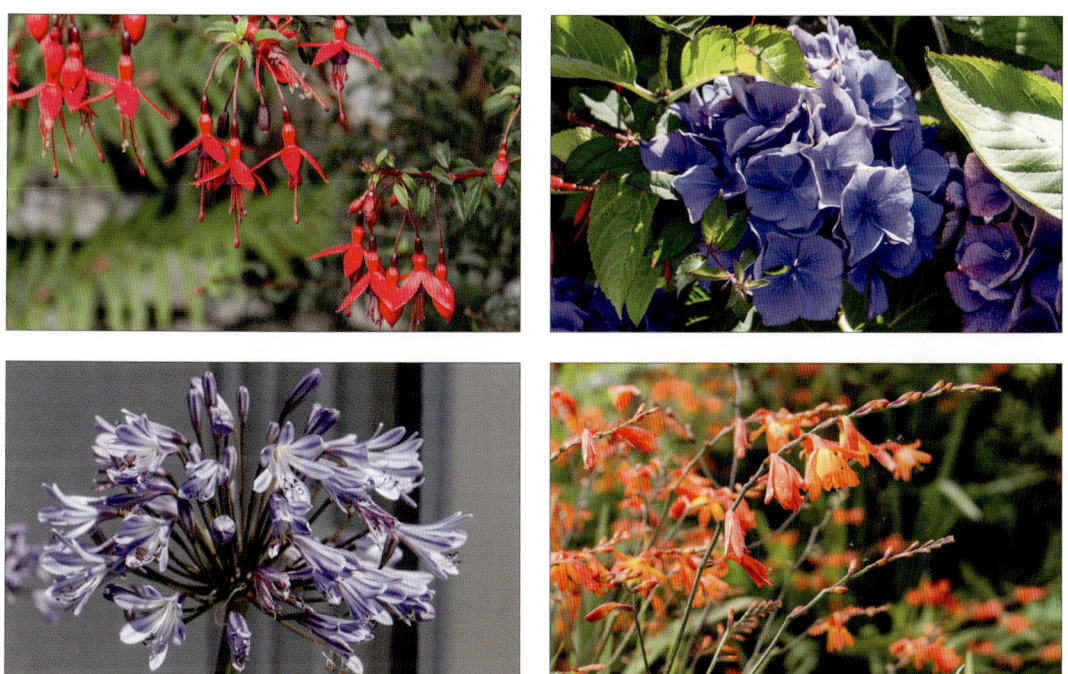

Colonsay is a fertile island with a generally mild climate. It therefore provides good growing conditions for many flowers such as, clockwise from top left, fuschia, hydrangea, montbretia and agapanthus.

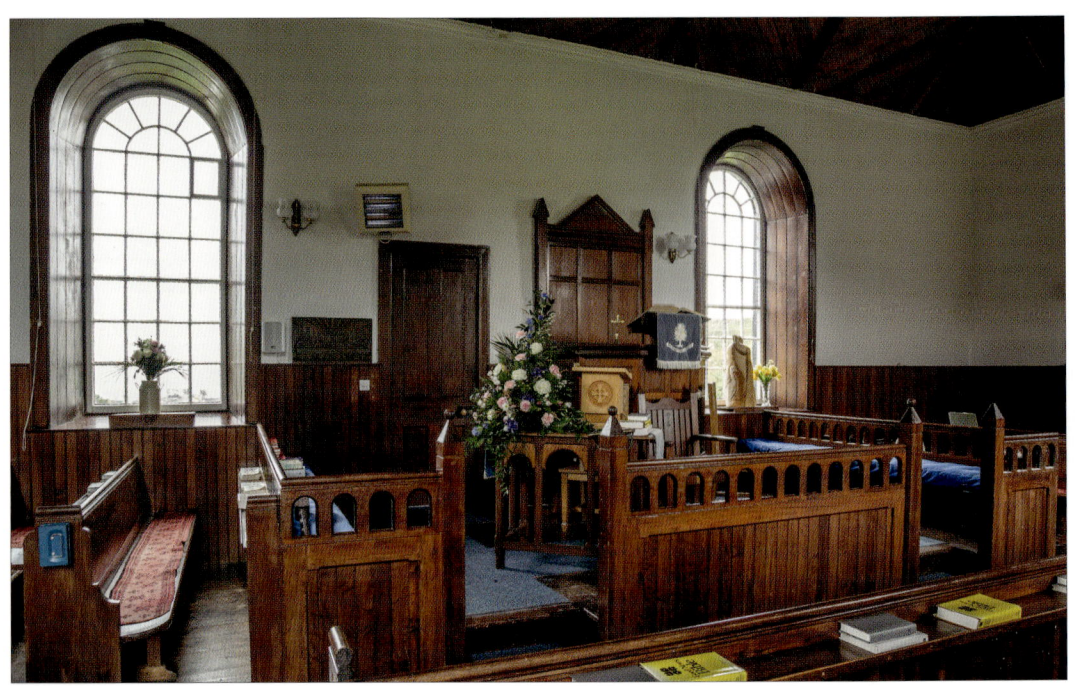

76 The beautifully maintained interior of Colonsay's Church of Scotland building, which stands overlooking Scalasaig, across the road from the hotel.

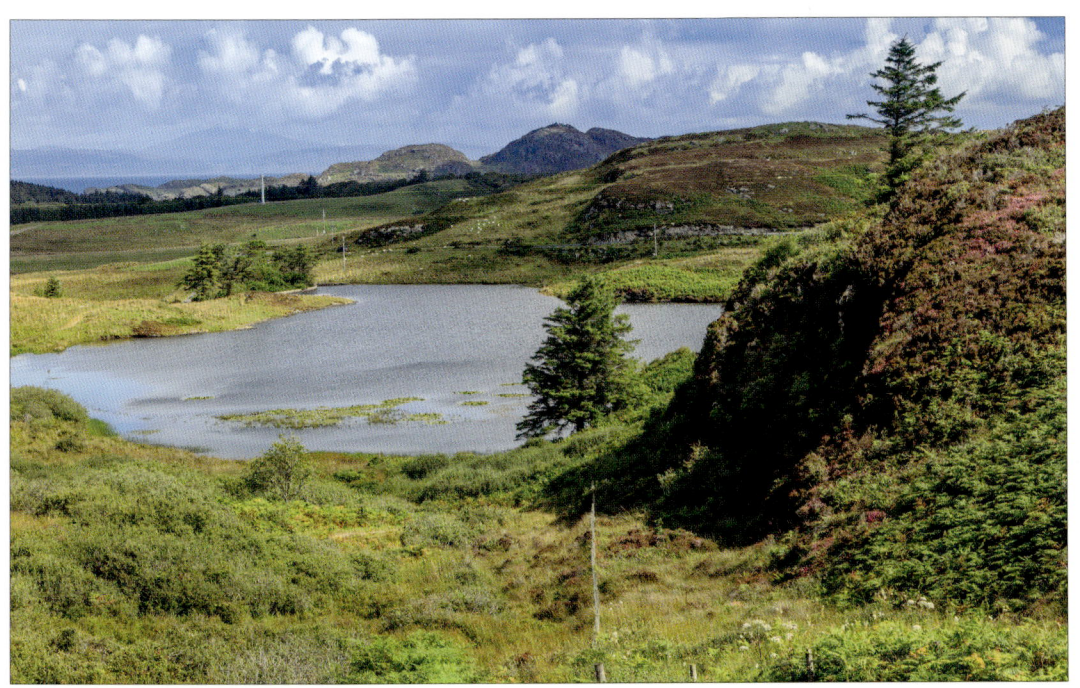

A useful track from behind the Colonsay Hotel in Scalasaig provides a short cut to the north of the island and also offers this pleasing view northwards which gives a good idea of the hinterland.

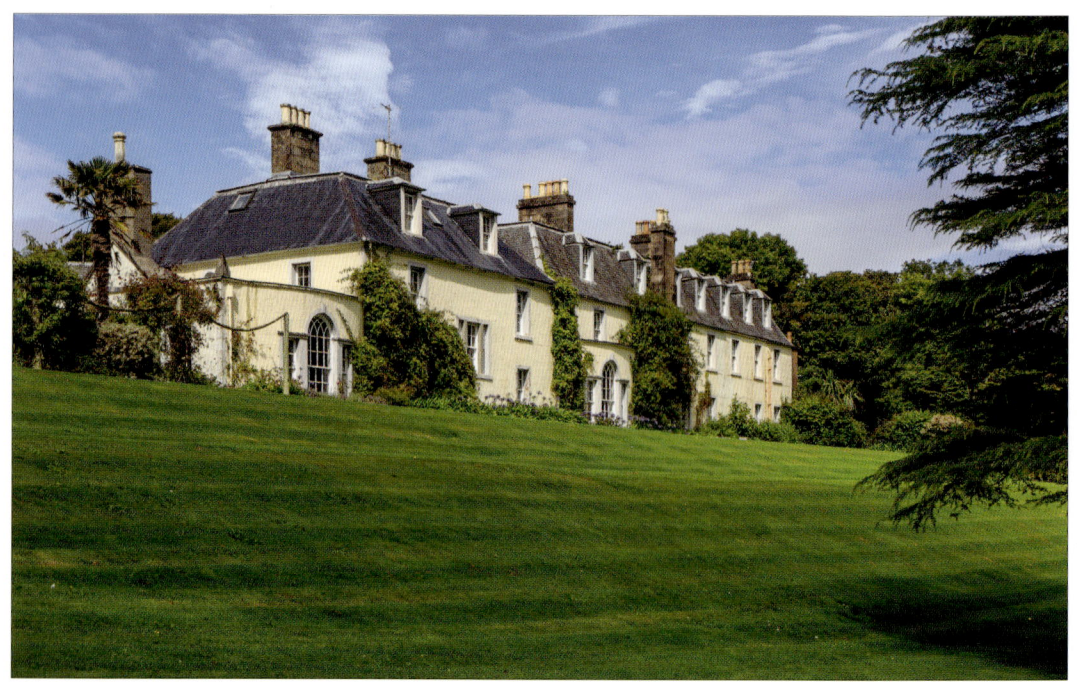

78 Colonsay House Estate is located towards the north of the island. The house was built in stages from about 1722 by the McNeill family. Since 1904 the house has been the property of the island's owners,

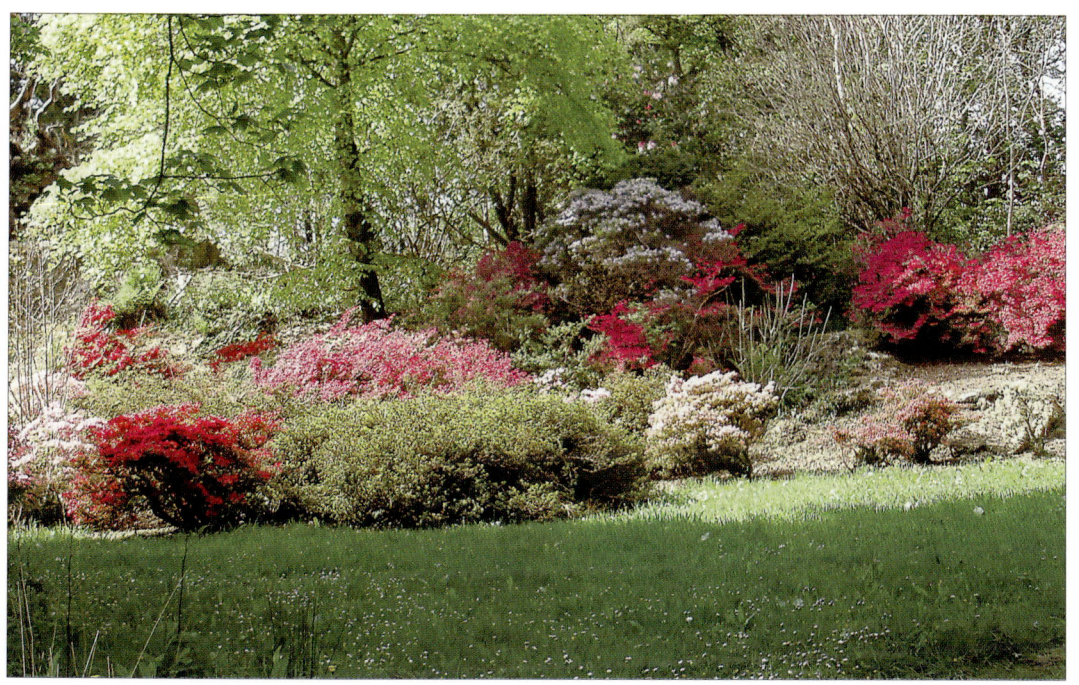

the Barons Strathcona. Its rhododendron and woodland garden is considered to be one of the finest such gardens in Scotland and was planted mostly in the 1930s. Pictured here is the dwarf azalea garden.

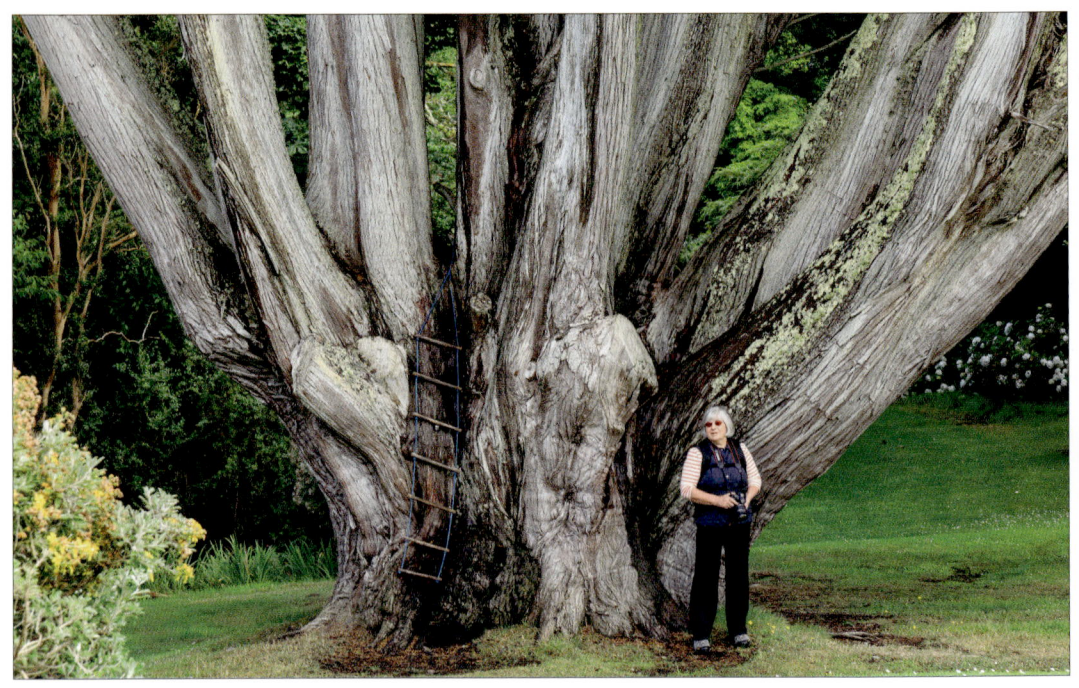

80 Arguably the garden's most impressive specimen is this gigantic tree, a Monterey cypress (*cupressus macrocarpa*). This is a rare tree, the conservation status of which is 'vulnerable'.

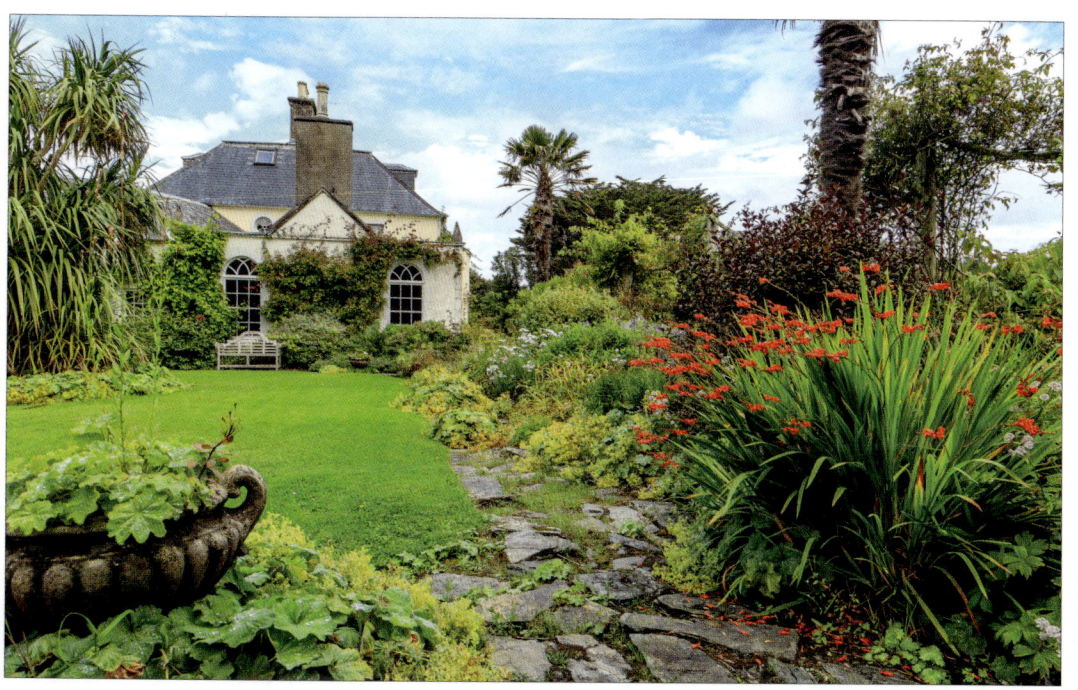

The charming area of the garden at the south-west end of Colonsay House, with crocosmia in full bloom on the right.

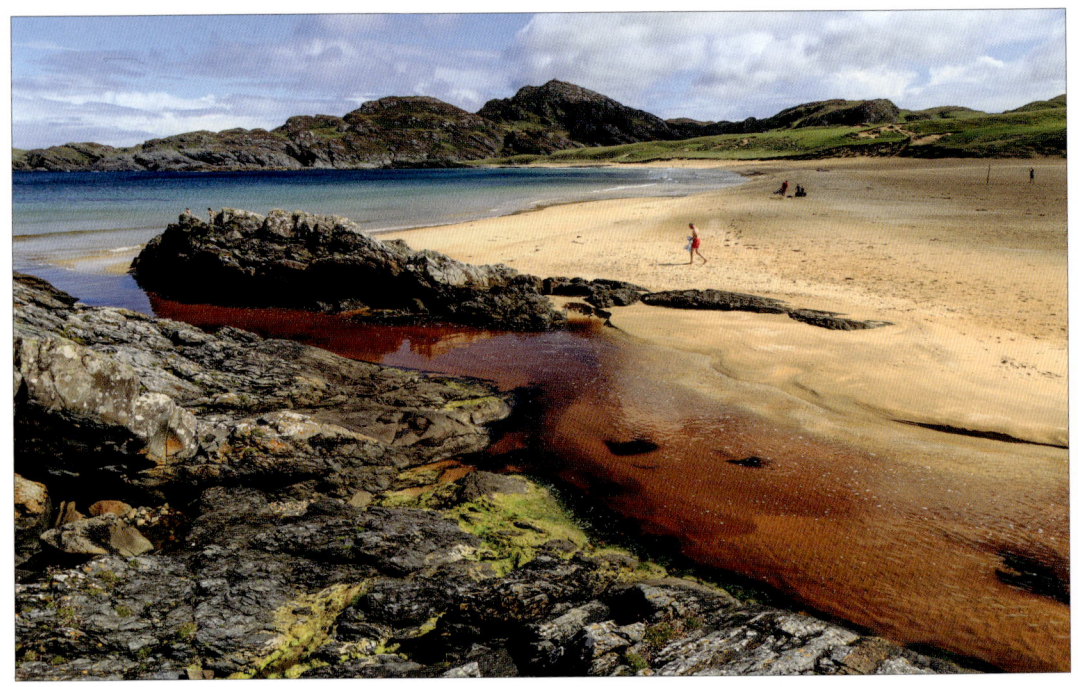

82 In a group of islands spoilt for choice when it comes to beaches, Colonsay's Kiloran Bay can stake a claim to being the best of all. This crescent of glorious golden sand is backed by craggy Carnan Eoin

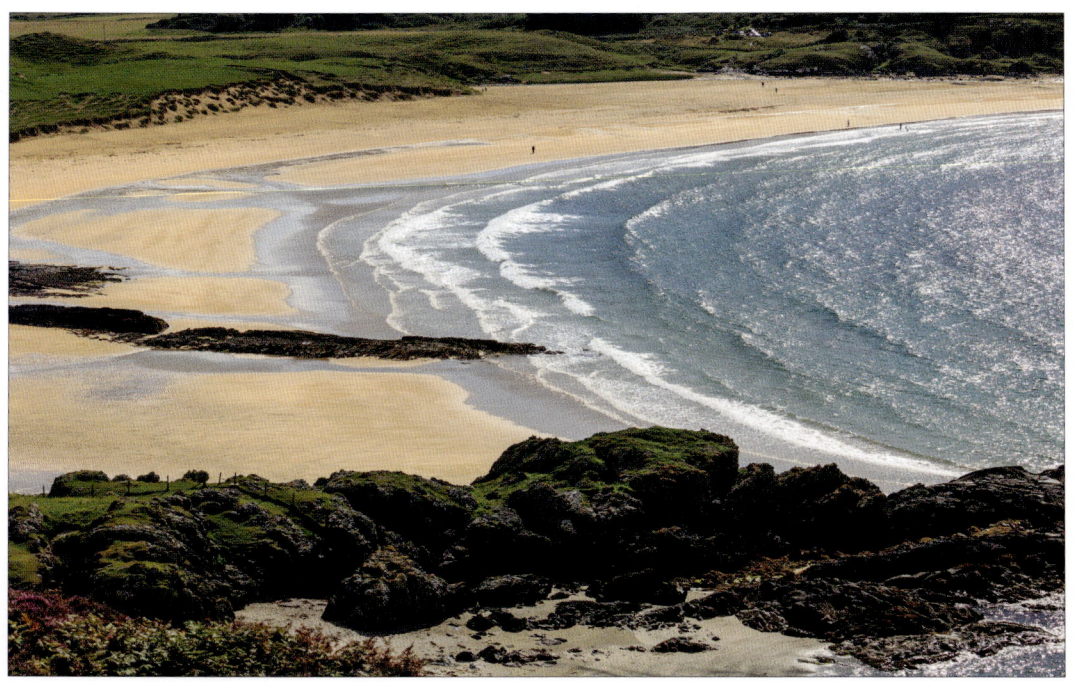

at its northern end, from the slopes or summit of which the opposite view (above) can be seen from a commanding height. The water is crystal clear and at most times of the year icily invigorating.

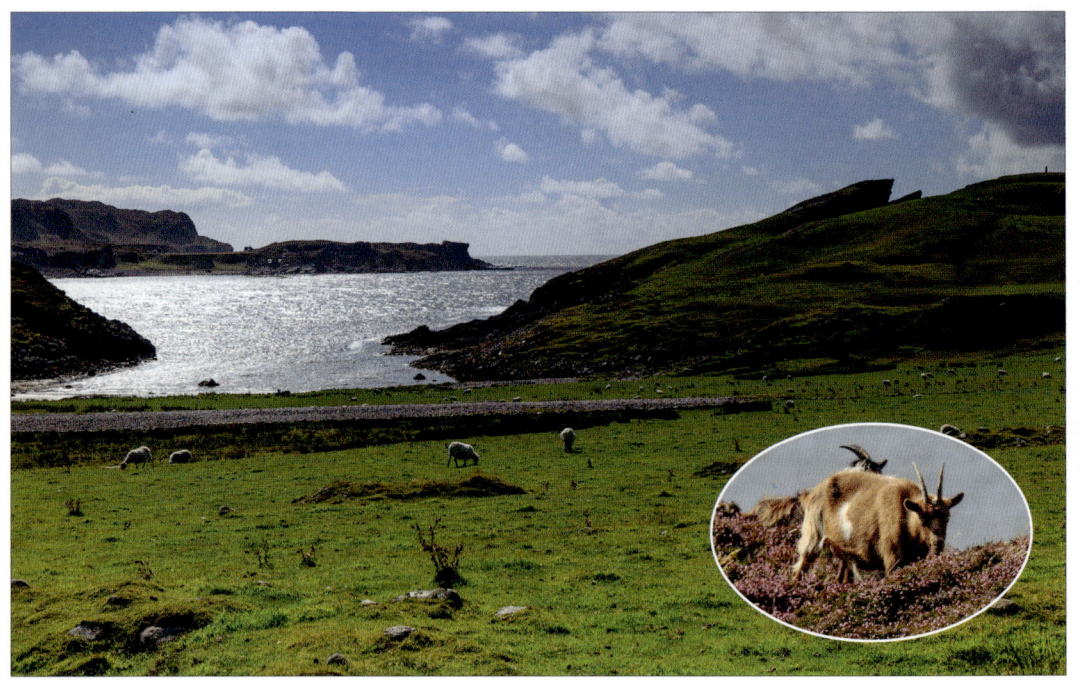

84 The track to the northern tip of Colonsay passes through scenery like this and may yield a sighting of wild goats, reputedly descendants of Spanish goats carried on an Armada vessel shipwrecked on Colonsay.

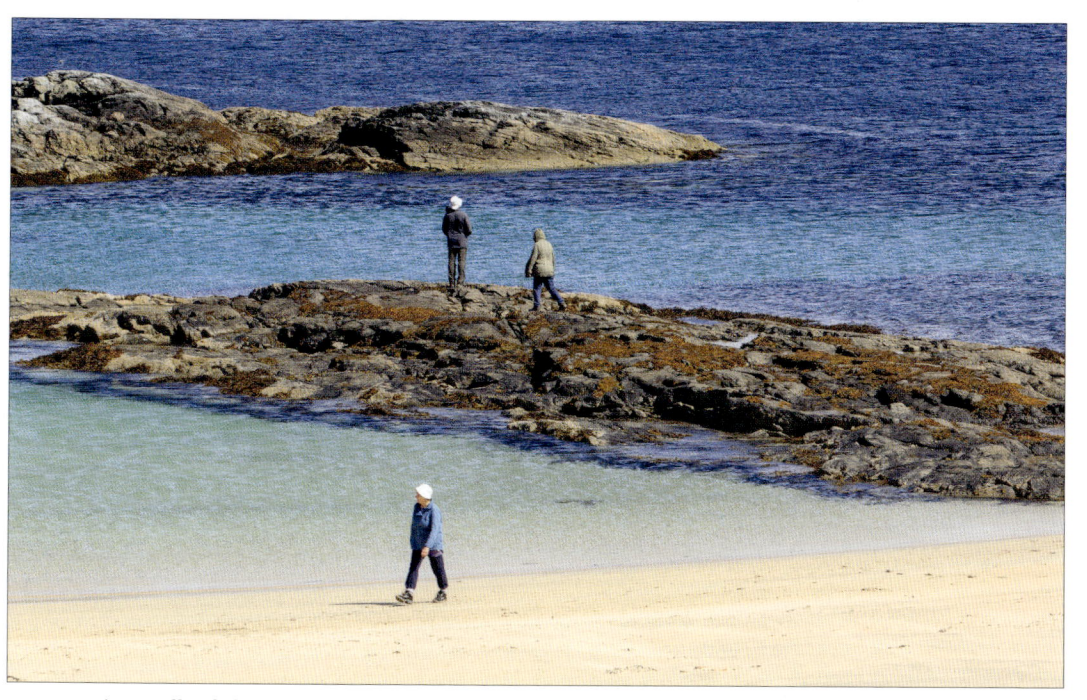

It's a walk of about three miles from Kiloran Bay to Balnahard Bay, where a beach of different character but similar qualities greets those who make the trek.

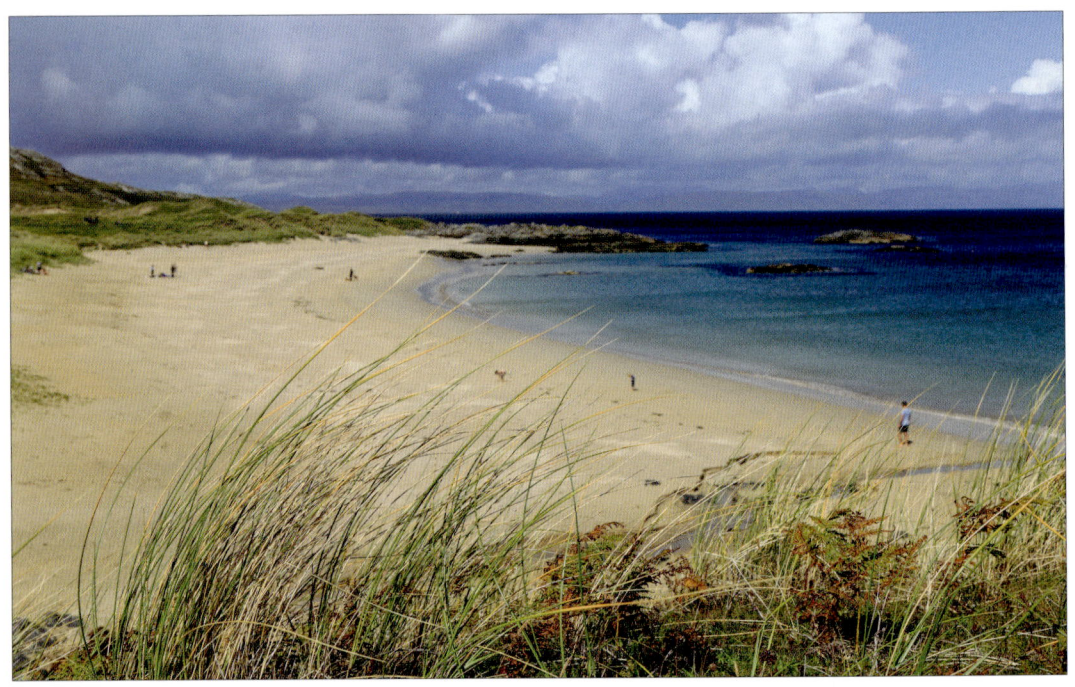

86 From this remote northern extremity of Colonsay, with the Ross of Mull visible on the horizon, we flit to the opposite end of the island for an adventure of a different kind . . .

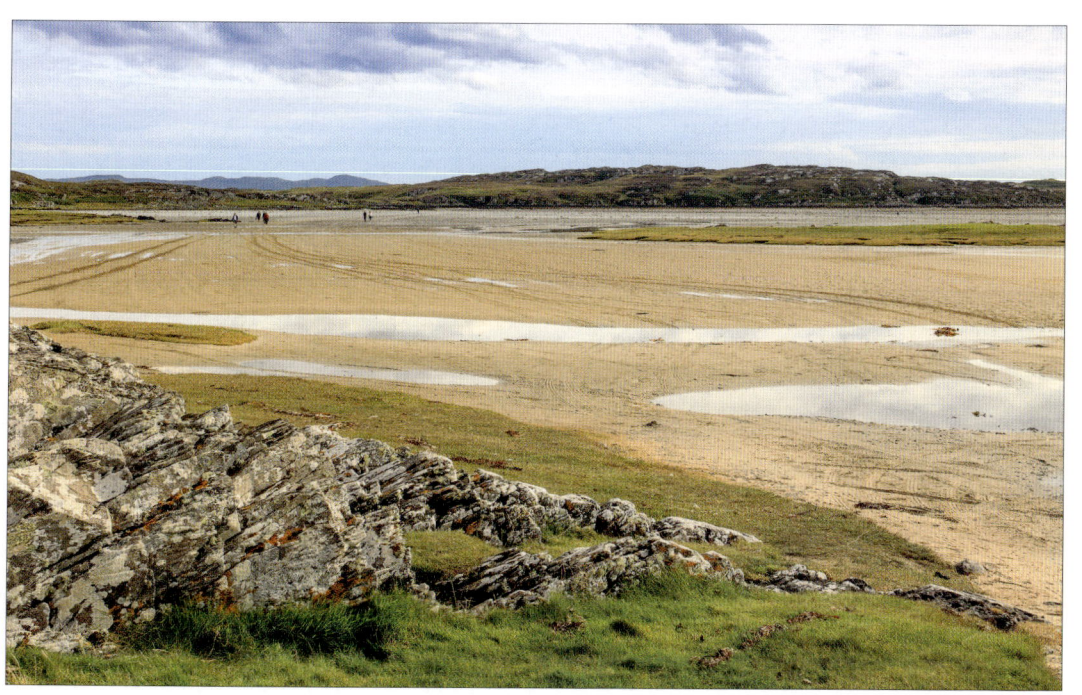

. . . yes, more sand, but at low tide this is not a place to linger, for this is The Strand which, at low tide, enables the adventurous to cross over to the neighbouring Isle of Oronsay.

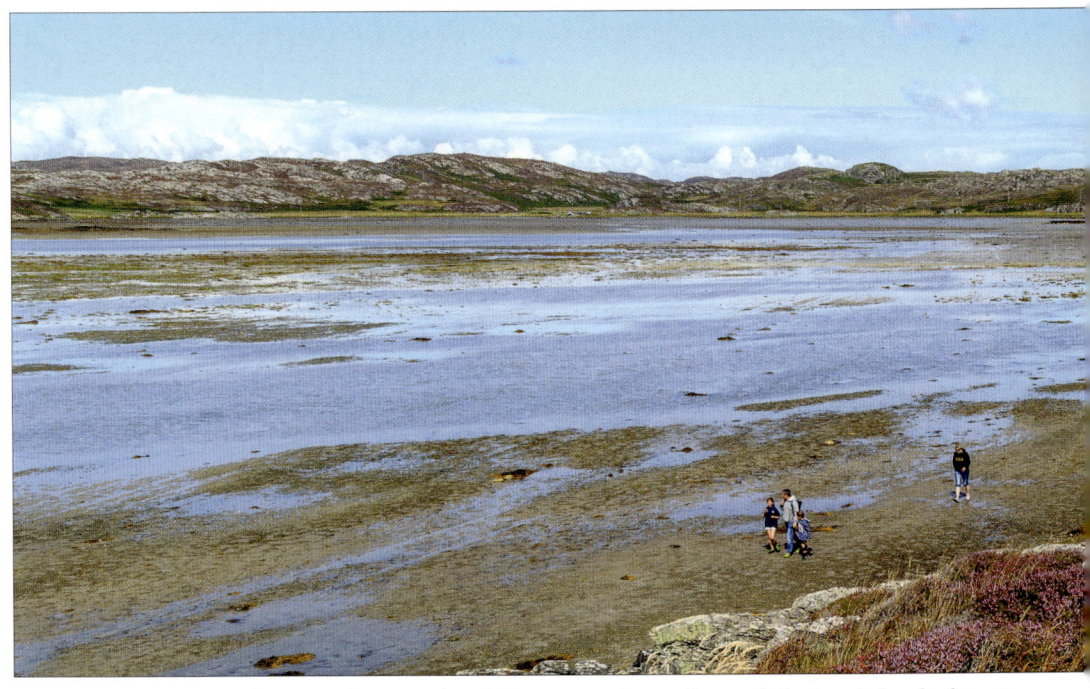

88 It's a little over a mile across The Strand and the crossing has to be carefully timed: local advice is to start around two hours *before* low tide, so as to be able to return no more than two hours *after* low tide.

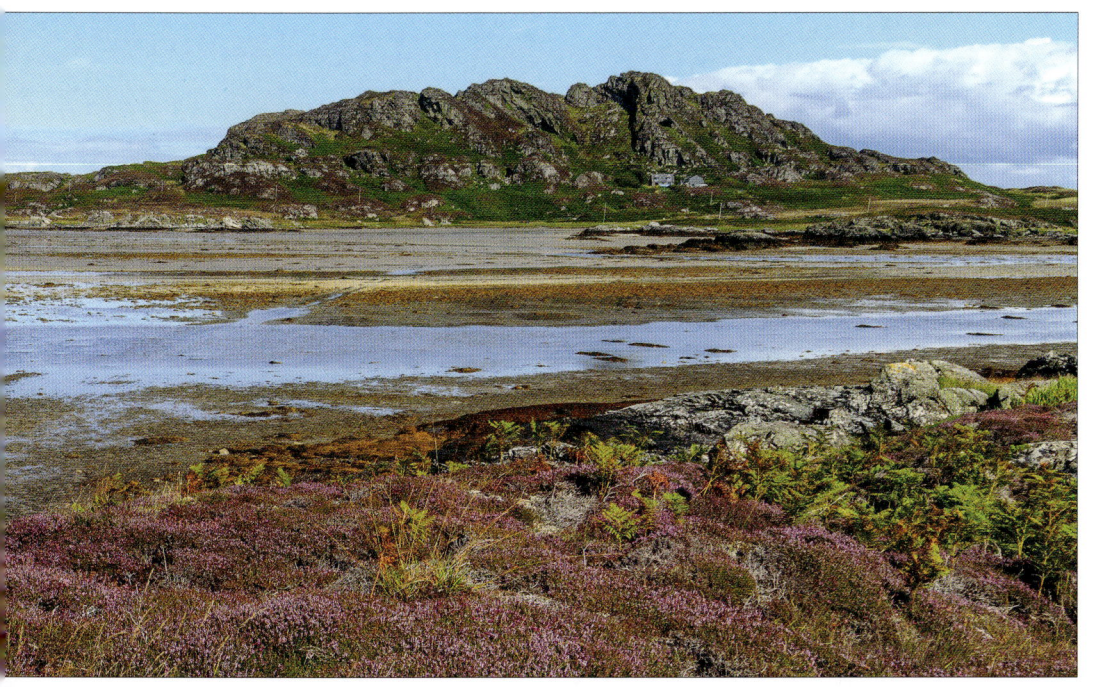

This four-hour 'window' is enough to visit the priory. The picture above looks back from Oronsay to Colonsay. As can be seen, the crossing is not dry throughout – wellies are best!

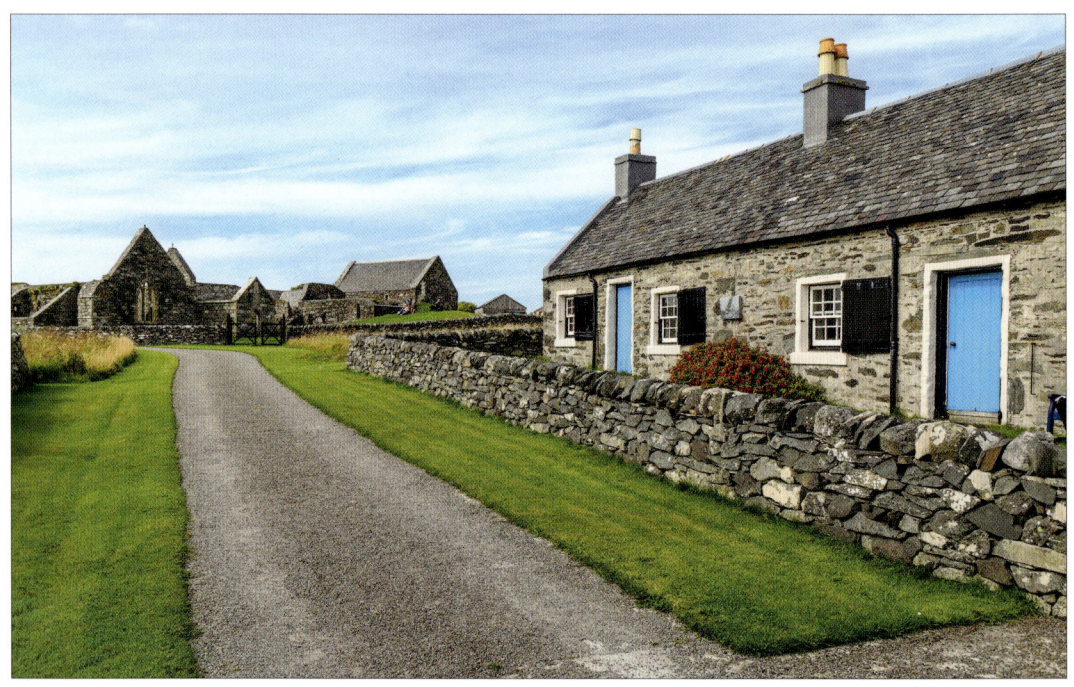

90 These days, Oronsay is a wild and virtually uninhabited island, so after walking across its empty brown terrain it's a surprise to arrive at this oasis of neat lawns and immaculate cottages . . .

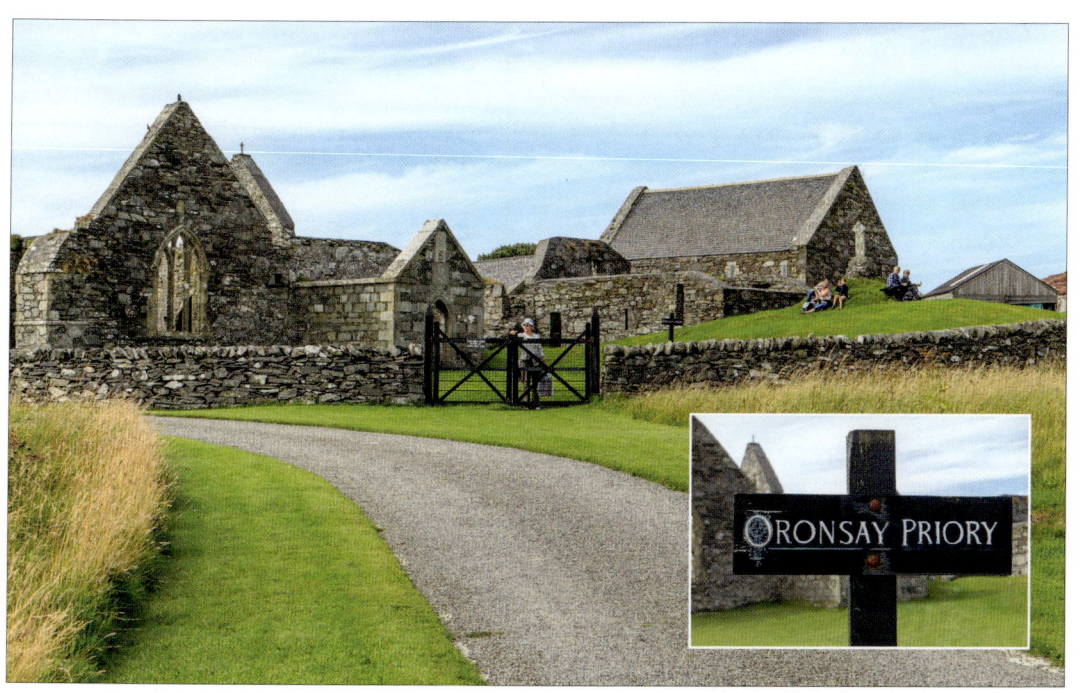

. . . for this is the well-tended compound of the small Augustinian priory, remarkable for being founded later than most Scottish monastic houses, in the second quarter of the 14th century.

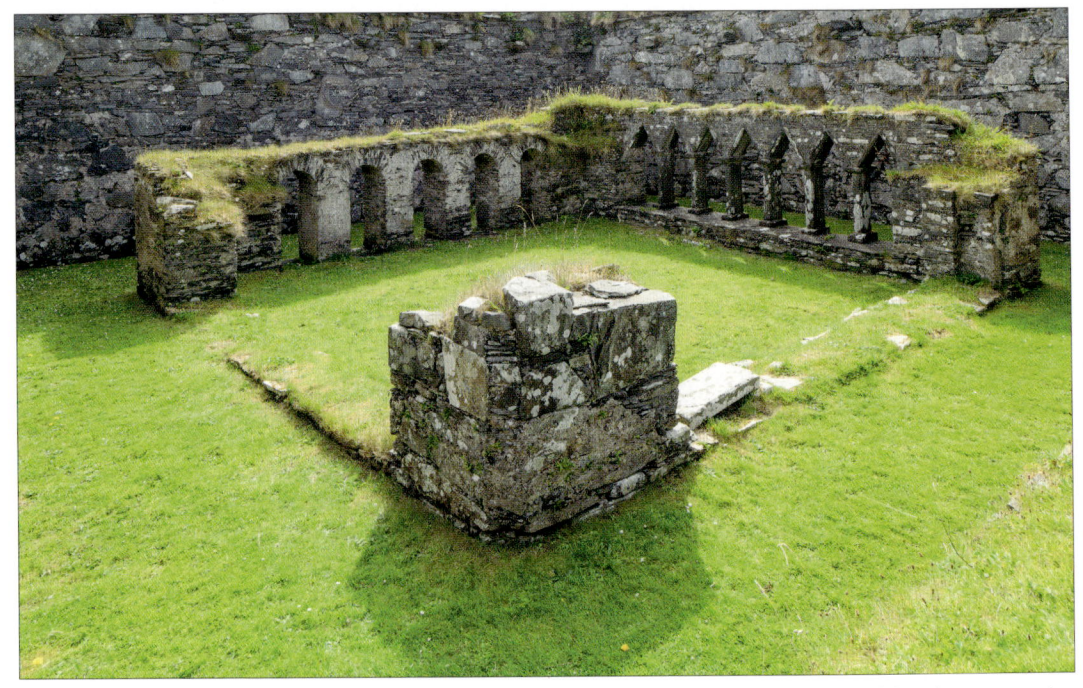

92 Soon after 1500 some restoration work was carried out, including reconstruction of the cloister-arcades which, as can be seen above, was not completed, hence the differing styles of the remaining arches.

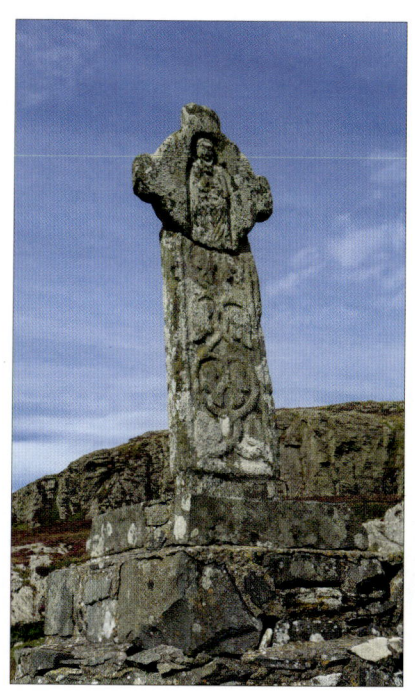 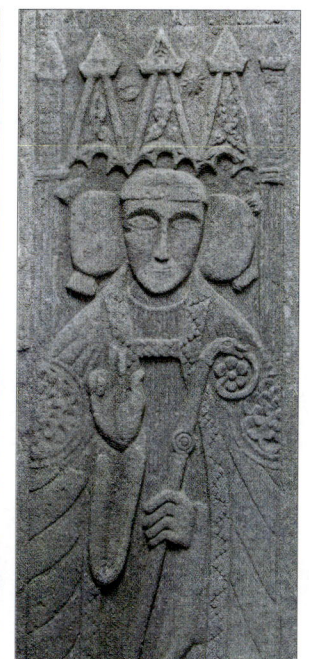 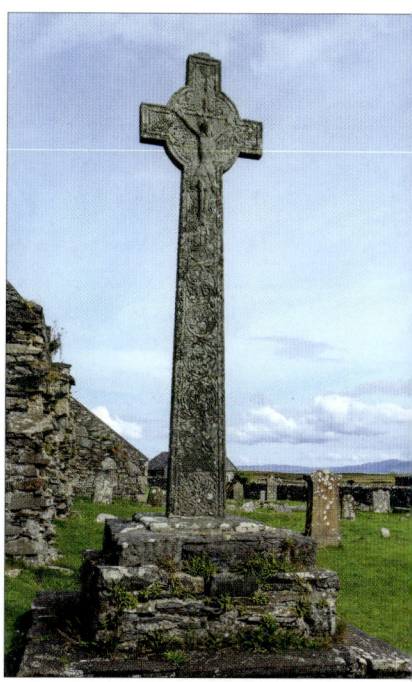

Left: the Little Cross at the priory could be much older than the priory itself. Centre: an example of a carved grave slab at the priory. Right: the Great Cross, made at the end of the 15th century in Iona.

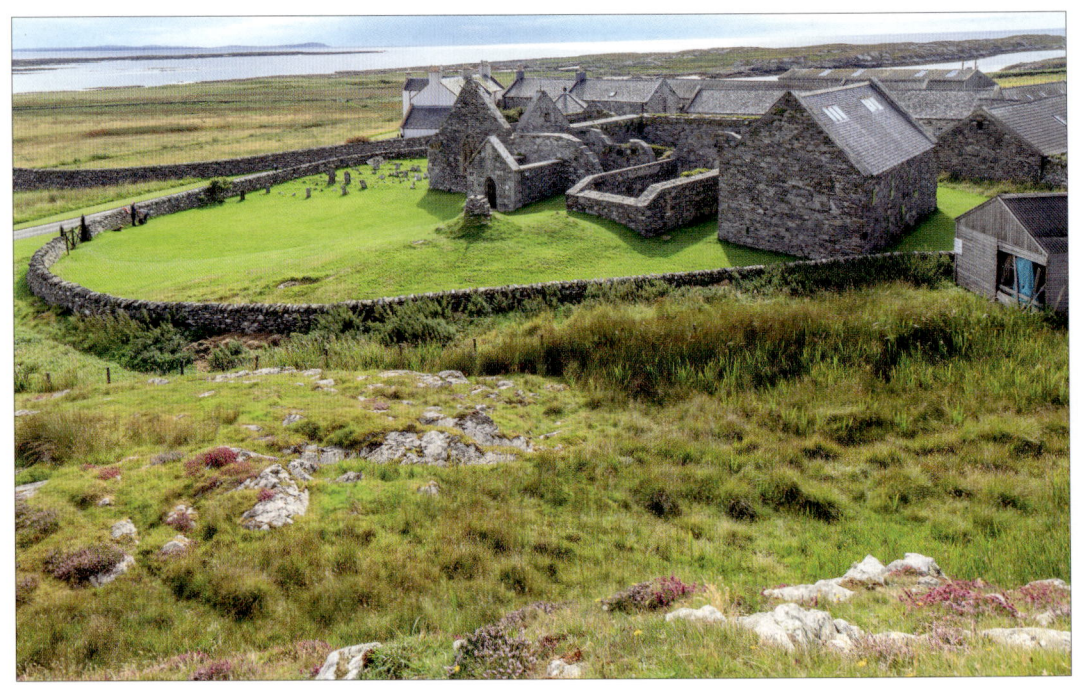

94 The priory viewed from the adjacent hillside. The roofed building on the right was the prior's house and today contains a wealth of grave slabs and effigies. Oronsay Farm buildings can be seen behind.

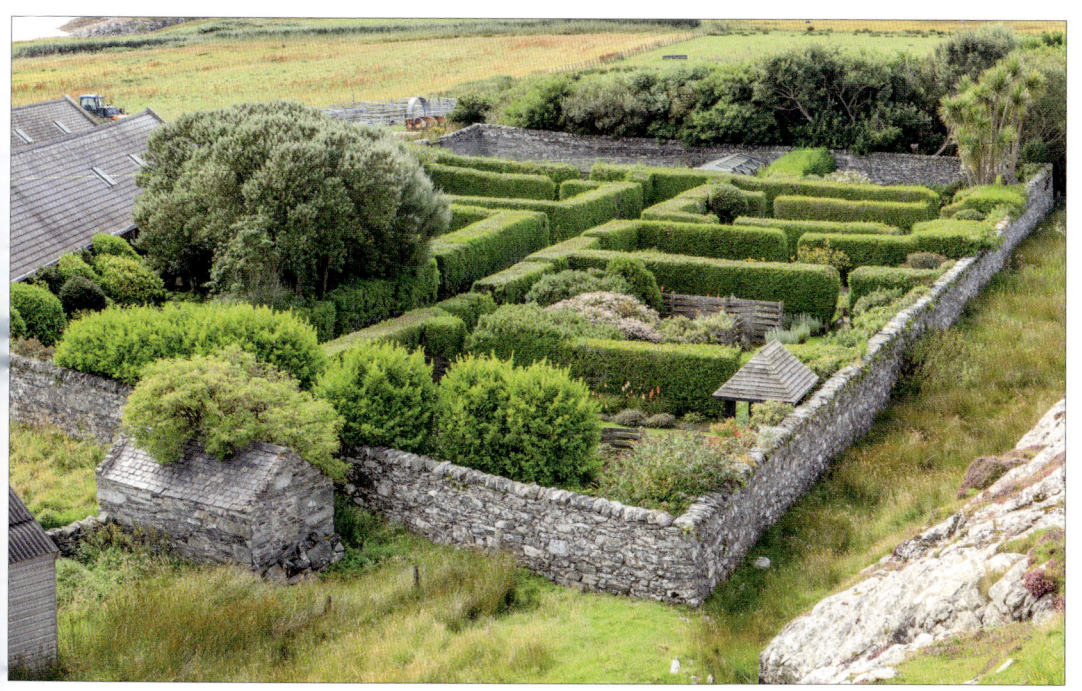

This lovely walled garden belongs to the farm. The image it portrays of crafted fertility is a good note on which to end our tour of Colonsay, Oronsay Islay and Jura.

Published 2018 by Lyrical Scotland, an imprint of Lomond Books Ltd, Broxburn, EH52 5NF
www.lyricalscotland.com www.lomondbooks.com

Originated by Ness Publishing, 47 Academy Street, Elgin, Moray, IV30 1LR

Printed in China

All photographs © Colin and Eithne Nutt except pp.16, 27 (lower left and right), 28 & 42 © Becky Williamson; p.58 © Sue M. Cleave; p.69 © David Philip; p.79 © Colonsay Estate

Text © Colin Nutt
ISBN 978-1-78818-021-4

All rights reserved. No part of this publication may be reproduced, stored in a retrieval system, in any form or by any means, without prior permission of Ness Publishing. The rights of Colin and Eithne Nutt as authors of this work have been asserted by them in accordance with the Copyright, Designs and Patents Act 1988.

Front cover: Kiloran Bay; p.1: white-tailed sea eagle; p.4: fulmar; this page: cloister detail at Priory; back cover: Colonsay sunset

While the Publisher endeavours to ensure the accuracy of information provided, no responsibility can be taken for errors or omissions. The publisher welcomes information should any be found.